DATE LOANED

THE GUM BICHROMATE BOOK

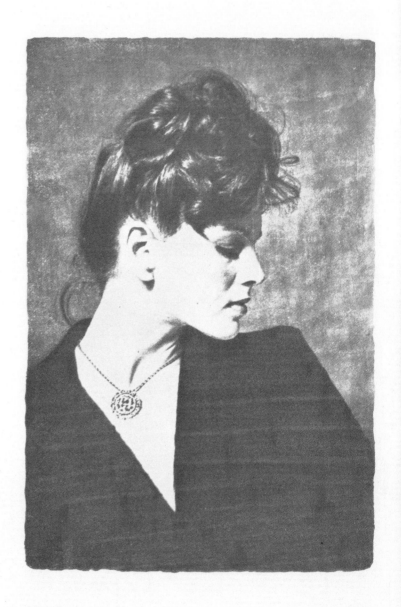

Artist's proof *David Scopick*

·THE·
GUM BICHROMATE

BOOK

contemporary
methods for ◊
photographic printmaking

DAVID SCOPICK

light Impressions
rochester new york

Published by
LIGHT IMPRESSIONS CORPORATION
Box 3012 Rochester, NY 14614

Illustrated by Michael Côté
Cover Illustration: David L. Scopick
Book and cover design by Marcia Smith
Editor: W. Paul Rayner

Printed by Mohawk Printing Corp.
Rochester, New York

With thanks to The Ontario College of Art; The Ontario
Arts Council; The George Eastman House; Andrew Stasik of
the Pratt Graphics Center; Christina Clarke of the George
Eastman House; Ed Doherty of British Drug House; Deli
Sacilotto of York University.

ABOUT THE AUTHOR

David studied photography at the Ryerson Photographic
Arts Center and the San Francisco Art Institute, and print-
making at York University. He has worked professionally
in commercial photography with T.D.F. Artists and Sher-
man and Law Ltd. and also as an independent commercial
photographer. He is presently a lecturer in applied and
contemporary photography at The Ontario College of Art in
Toronto.

10/9/8/7/6/5/4/3/2/1

Library of Congress Cataloging in Publication Data
Scopick, David, 1944—
 The gum bichromate book
 Bibliography: p.
 1. Photography—Printing process—Gum-bichromate.
I. Title.
TR445.S36 773'.5 78-8122
ISBN 0-87992-010-6

Table of Contents

Preface

My concern in compiling this text came from my own work in photography and a need for information that described the gum bichromate process. With an interest in attempting to learn the methods, I became aware of the problems in deciphering the early texts. Suggestions for using such outdated material as "Whatman cold-pressed medium paper" along with vague references to quantities such as a "thimbleful" of sensitizer made the process difficult to understand and incompatible with modern materials and working methods. It soon became obvious that a contemporary manual was needed.

Since the photographer working with the gum bichromate process uses materials not regulated by the photographic industry, he enjoys a freedom from the whims of the photographic manufacturer. His personal taste and feeling may also be expressed to such a degree that each print from the same negative may possess distinct, individual characteristics, unlike those attainable with commercially-made materials.

Each print may possess distinct characteristics

The process itself is not difficult. It is extremely flexible and can become confusing because of the great number of variables inherent in the medium. But anyone working systematically, operating along definite lines and varying one element at a time, will find no difficulties and that the resulting beauty repays the necessary effort. It is also of particular appeal to individuals who enjoy carrying out all aspects of a process which allows so many alternative means of printing. Thus each worker is able to discover unique talents for the development of good images, incorporating and modifying new principles with his own hands. Laszlo Moholy-Nagy states:

> The enemy of photography is the convention, the fixed rules of the "how-to-do." The salvation of photography comes from the experiment. The experimenter has no preconceived idea about photography. He does not believe that photography is only as it is known today, the exact repetition and rendering of the customary vision. He does not think that the photographic mistakes should be avoided since they are usually "mistakes" only from the routine angle of the historic devel-

I

opment. He dares to call "photography" all the results which can be achieved with photographic means with camera or without; all the reaction of the photosensitive media to chemicals, to light, heat, cold, pressure, etc.[1]

The revival of gum printing

Gum printing and the other "pictorial" processes last enjoyed widespread popularity at the turn of this century, with the pictorial photographic movements in Europe and North America. There is now a revival of these interesting and beautiful processes, although many photographers today have never seen a gum print. This is not to discourage anyone wishing to work with gum bichromate, since it is not necessary in order to use the method successfully.

The entire process is explained within the text. In regard to the necessary materials, I most often use general terms to reduce the problems of product selection. Sensitometric explanations are also avoided, as I describe the process in a traditional sense, thus giving a preference to visual terms and working methods.

Introduction

Gum bichromate printing prevailed at a time in photographic history when processes were changing rapidly. Many of these methods are now within a category of printing processes which are most readily found under the classification of "obsolete" in photographic dictionaries. They involve methods of making positive prints by exploiting the various physical changes produced in a bichromated colloid* by the action of light. Certain organic colloids, e.g. albumen and gum arabic, sensitized with a bichromate such as potassium or ammonium, change their physical character when exposed to light. Three principle changes may take place in the colloid: it may no longer absorb water and swell up; it may lose its surface tackiness; or, if previously soluble it may become insoluble.

The principle processes based on the swelling of the colloid are bromoil and oil printing. In these, following contact exposure under a negative, the layer of colloid is bathed with water so that the unexposed areas swell and become waterlogged. A greasy ink which is then applied with a brush is rejected by the swollen areas and accepted by the exposed unswollen colloid to form an image.

The dusting-on or powder process is based on loss of tackiness. In this, a bichromated colloid such as gum arabic is exposed under a negative and "developed" by being lightly brushed over with a finely powdered pigment. Where the light has acted, the surface loses its tackiness and the pigment does not adhere. Thus an image is formed only on tacky, unexposed areas.

The principle processes based on the change in solubility of the colloid are: carbon, carbro, and gum bichromate. *Processes based on change of solubility*

Alphonse Louis Poitevin (1819-92), a French chemist and photographic inventor, is credited with the discovery of the principle involving the action of light on chromated colloids in 1855. John Pouncy (1820-94), an Englishman, first took

See Glossary. Throughout the remainder of this book, an asterisk refers the reader to the Glossary.

3

Poitevin's theory and developed the gum process, about 1856.[2] However, it did not reach full popularity until forty years later when used by Alfred Maskell of England and Robert Demachy of Paris, who are credited for naming the process the Photo Aquatint. Between 1894 and 1900 they worked extensively with the process, becoming its leading exponents, first with single and then later multiple printings. From their endeavors, the process became widely popular for the next twenty years.

Gum printing seemed particularly suited to accomplish the new ends to which photography was being put at this time. Several new processes, or variations on old processes, *Extending the range* came into being, extending the range of manipulation *of manipulation* available to the photographer. These manipulations were of two types. The first were changes introduced directly to the negative, which might include distortion through abnormal exposure or development; e.g., overexposure causing reversal of the highlights which severely altered the way in which volumes and spaces were modelled. Perhaps the most apparent to the untrained eye were those introduced by scratching or other handwork on the film itself, as done by Frank Eugene. The second form of change was introduced at the point of making the print, as in the case of gum printing. Such manipulations served to photographically evoke styles that the secessionist photographers found attractive in painting and the related graphic arts. All of this required stepping beyond the conventional means of producing photographs. This freedom with which parts of the image could be removed or altered in tone caused the process to be subjected to severe criticism in its early history. Some critics went so far as to declare that prints so produced could not be called photographs. Because of this philosophical and visual kinship to the traditional fine arts of the period, photographs made during that time have often been called pictorial, high art, or salon photographs. It is now well documented that the medium of photography was practiced by numerous late-nineteenth century artists. Among the most noteworthy was Edgar Degas (1834-1917), who adopted the impressionist compositional device of the close-up borrowed from photography. Many artists left painting for photography; Edward Steichen, Gertrude Kasebier, and Alvin Langdon Coburn are among the better known.

As explained in the text, gum printing requires a negative the size of the desired print. This can be produced either in a camera, or indirectly from a small format negative by means of a suitable mechanical method. A selected print paper is then preshrunk* and sized* with a transparent, flexible coating and sensitized with an emulsion of gum arabic, ammonium dichromate, and watercolor pigment.

4

The print is made by exposing the negative in contact with the sensitized paper.

Development takes place in plain water where the unexposed areas dissolve and dissipate. The image at this time is susceptible to a wide variety of manipulations. Because this phase of the process may be done under normal light conditions, any such techniques are directly visible.

Development in plain water

When development is complete the print is air-dried, during which time the image will harden and become permanent. The customary procedure is then to resensitize the paper with a second emulsion*, reposition, and re-expose through the negative. The print is then redeveloped and manipulated as desired, repeating the process until a satisfactory print is obtained.

When the image has dried following the final printing, it is made permanent by soaking in a clearing bath* followed by a running water wash. Finished prints will be of archival quality, having only the watercolor itself left on the paper surface. Because of this they will last as long as the support exists. All the unique characteristics of a watercolor painting are possible, e.g. subtleties of transparent and opaque color, brush strokes, paper selection, and so on. The modifications to the process are so numerous that no two artists work alike.

Archival quality

The materials and chemicals required for gum printing are commonly available and inexpensive, allowing for a very low cost per print. Overall cleanliness is easily maintained, since the watercolor, dichromate sensitizer, and gum arabic emulsion are all soluble in water.

Halftone* negatives are not required for continuous tone* images in gum printing as with gravure, lithography, or serigraphy. (For an explanation of these terms, refer to appendix C.) This will be particularly encouraging for anyone having used cumbersome methods requiring a process camera. It follows that no printing press or special facilities are required, and the process may be carried out in any conventional darkroom.

5

Equipment and Materials

The following represents a list of materials, abbreviated for easy reference, followed by more detailed descriptions of each item to aid the worker. The brand names when mentioned are those found to be readily available in my area. You may use these or try other products from differing manufacturers to find their suitability. A detailed explanation of chemicals is given in Appendix D.

Enlarger and Standard Darkroom Equipment

Red safelight filter
Contact printing frame
Light box
Small measuring graduate
Glass dropping bottle
Plastic dropper jars
Chemical balance

Film and Chemicals for Enlarged Negatives

Duplicating film
Bromide paper developer

Printing Paper

Artists' intaglio paper

Paper Size

Gelatin
Formaldehyde

7

Brushes

Oil paint brush
Watercolor brush

Color Pigments

Watercolor in tubes or powders

Emulsion Binder

Gum arabic solution or powder
Mercuric chloride (for powder only)
Distilled water (for powder only)

Sensitizer

Ammonium dichromate

Clearing Bath

Potassium metabisulphite

White Light Source

Photoflood

In the following detailed list the quantities mentioned are based on the minimum amounts commonly available from suppliers.

Enlarger and Standard Darkroom Equipment

A small format* enlarger is adequate, although you may find certain restrictions in making the required enlarged negatives as described in Step One. The value and capabilities of a 4" x 5" enlarger for general use in photography are commonly underrated. It is one of the more valuable pieces of equipment for the production of special printing techniques.

It is necessary to have print developing trays of proper dimensions to accommodate the paper you expect to print on. Keep in mind that this is about one size larger than that of the negative itself, owing to the larger borders that are customary with prints of this nature. A negative size of 8" x 10" is well suited for printing on paper cut to 11" x 14".

Any timing devices that may be used are an asset to

accuracy, although not totally essential. Along with a print easel, such items are beneficial in lessening the effort required in production.

Red Safelight Filter

All film materials mentioned for use in making the enlarged negative are either orthochromatic* or blue-sensitive.* Unlike panchromatic* emulsions these may be handled under a red safelight. Be certain to follow the film manufacturer's data for the allowable distance and strength of the bulb. Safelight filters should be replaced periodically, as fading occurs over a period of use.

Contact Printing Frame

To ensure the accurate registration* of the image for the methods used in multiple printing,* only certain types of contact printing frames are suitable. Of those commercially made, one which has the glass contact plate hinged on the end and which is lowered and clamped over the negative and paper provides for the most accurate registration. Of the various other types available, such as those with a removable hinged back, be careful to prevent disturbing the print registration while securing the clamping spring — an error which may pass unnoticed until too late. It may be necessary to devise methods of securing by taping the negative and paper together.

Hinged glass contact printer

If you wish to avoid purchasing a frame, it is simple enough to construct one. You can even use a large sheet of heavy glass. (Weights may be required on the corners to ensure good contact.) When selecting a frame, it is essential that it be several sizes larger than the negatives you expect to work with, as mentioned for the print developing trays. Frames that use a plastic (as opposed to a glass) contact plate are very susceptible to scratches and costly to replace. If the frame has

Spring back contact printer

9

a sponge base, you will likely find that it does not provide adequate pressure for high quality contact printing.

Light Box

Although a light box is a common piece of photographic studio equipment, many workers do not own one. In gum printing, it is required for examining the enlarged negatives, masking, opaquing, and performing several other necessary functions. Because it will not be used for any color correcting procedures as far as this process is concerned, the more accurate and expensive light box is not required. Owing to the

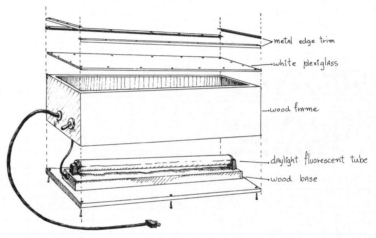

Light box assembly

relative simplicity of its construction and the great reduction in price of an expensive item, I urge the worker to construct his own light box.

Small Measuring Graduate

In addition to the usual darkroom measuring graduates, at least one additional graduate will be needed. It should be glass, accurate to +.5ml and capable of measuring up to 25ml.

Glass Dropping Bottle

Dispensing the sensitizer from a dropping bottle will help to accurately measure the small amounts required in gum printing. A burrett, pipette, or syringe are suitable subsitutes, accomplishing the same function when used with any regular container.

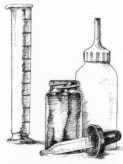

Small measuring graduate, glass dropping bottle, plastic dropper jar

Plastic Dropper Jars

These jars will prove to be a convenience in the preparation and use of the emulsion. They are not to be confused with the glass dropping bottle. They require a pressure-squeeze operation and have a small narrow dropper outlet. The worker, in using them to mix and store the emulsion, will avoid the problem of preparing a fresh mixture for each print. Although the total number of jars required will increase depending on the size of color "palette" used for printing, about six in 150ml size will be sufficient to start.

Chemical Balance

Early texts prescribe measuring pigments by inches squeezed out from tubes and powder quantities taken by the "thimbleful." Your measuring techniques must be more sophisticated than such methods allow. Time and effort taken for proper measurement will produce repeatable results and eliminate a lot of variables when problems arise.

Chemical balance

Although the most elaborate scale will not be necessary, a fair degree of refinement is desired. A triple beam balance capable of measuring up to 500g and accurate to .05g will be satisfactory.

The chemical balance will constitute a significant expense for gum printing, but its wide use in all methods of photography makes it a useful investment.

Film and Chemicals for Enlarged Negatives:. Duplicating Film

(25 sheets 8" x 10")

The highest quality negative for any process is an original, which for gum bichromate printing requires the use of a large format camera. However, you are not confined in your approach to this since there are alternative methods of producing the enlarged negatives from a small format camera.

The simplest method for this involves the use of duplicating film*, which provides an enlarged negative from a smaller negative without an intermediate positive. A product such as that manufactured by Kodak is suitable. A description of this and alternative procedures using various materials is covered under Step One.

11

Bromide Paper Developer
(5 liters)

The necessary soft negative quality that is suitable for gum work can be obtained using a regular bromide* paper developer such as Kodak's Dektol.

Printing Paper:
Artists' Intaglio Paper

Although it is possible to apply the gum bichromate emulsion to a variety of surfaces, I recommend that you begin by working in the traditional manner on paper.

Obtaining the proper paper

The most important concern in selecting a paper is that it must be able to retain its aesthetic appearance and avoid tears when repeatedly soaked in water. Printing paper sold as intaglio* or lithographic* paper is manufactured with these considerations in mind. Art stores carry a broad selection, and the varying differences are similar to those of photographic papers.

Also of prime importance is the paper's chemical purity, that is, its pH value or acidity, which determines just how stable the paper will be. PH value is used to indicate the alkalinity (by a figure above 7), or acidity (by a figure below 7), of an aqueous solution. The purest papers are commonly referred to as having a pH value of 7, the same neutral designation as water. The most permanent paper is made from linen rags, although a small amount of cotton is permissible. Care must be taken in the storage and handling of the paper since any physical contact with other than a chemically neutral container may cause contamination.

Utilizing a range of paper textures can broaden the effects of your work. Coarse, rough papers diffuse the image with a loss of detail. Smooth papers, provided they have an adequate tooth for holding the layers of gum, aid sharpness and increase contrast. Unlike in relief or intaglio printing, the paper's weight is not an important factor.

A recommended paper is Rives BFK, made in France.[3] Its appearance is classic, and it possesses all the characteristics necessary for gum printing. Owing to its established reputation, it is available at most art stores. For your initial testing, however, you may prefer to use a less expensive watercolor paper. (At a more advanced stage, colored papers of good stock may be used to advantage. Keep in mind that if you are printing from a negative on a dark paper using a light pigment, the image will appear negative.)

Paper Size

Paper is a finely webbed mass of interlaced fibers. Because

the structure is so absorbent, raw paper must be impregnated with sizing to permit the application and manipulation of liquid paints upon it. Examples of totally unsized papers are those used for blotting or filtration purposes. As a general rule, sizing improves any raw paper. It fills up the pores, keeps the image on the surface, and in some cases increases the sensitivity of the paper sheet.

The material used for sizing by manufacturers is a weak solution of gelatin or hydrous animal protein that is added to the paper while it is in the pulp stage. For gum printing, the manufacturers' sizing is so poor that it is not adequate for printing. Further sizing to keep the emulsion from staining the paper must be done before printing begins. The more common sizes are colloids* such as gelatin, arrowroot, or starch. The paper can be floated on one of these or the substance may be brushed over the surface. Gelatin is more suitable than arrowroot or starch.

N.B. Although the use of gelatin as a paper size is the preferred method of preparing the paper for gum printing, the laborious efforts required may be discouraging for beginners. A useful means for any initial work (or when sized paper is *An easy method of siz-* required in a hurry), is to coat the paper with a mixture that *ing* consists of approximately two parts Liquitex gesso, one part Liquitex acrylic matte varnish and one part water. (Not all brands of gesso and varnish are suitable.) A dilute solution of a latex based glue such as Elmer's can also work well. Using a brush, apply two coats to the front of the printing paper, allowing it to dry between each application. The paper's tendency to curl when wet on one side may be reduced by first lightly moistening the back of the paper with water, using a sponge, before applying the size.

Gelatin
(100g)

The property of gelatin which makes it valuable in the sizing of printing paper is that a hot solution, when cooled, will set to a flexible gel without destroying the aesthetic look of the paper. Only gelatin of the U.S.P. grade should be used. It will form a clear "water-white" gel when mixed with water, owing to the fact that as a higher purity gelatin it has been bleached and refined. Use of gelatin purchased from a grocery store may sometimes lead to yellowing of the paper support in time. This problem will not occur even in sunlight with highly refined gelatin.

Formaldehyde
(500ml)

The gelatin size softens when immersed in water and melts at about 32°C. It alone is impractical for the high water

13

temperatures necessary for gum printing. This and other problems that may result, including fungus growth on the gelatin protein, may be avoided by hardening or "tanning" the gelatin. In contemporary gelatin-based negatives and prints, hardeners* are used to prevent frilling, blistering and reticulation.*

The usual hardening agents are chrome alum, potash alum and formaldehyde. Formaldehyde is the most efficient choice for this process. In addition to its superior hardening qualities, it is capable of providing a more uniform coating than the alternative alum hardeners.

Mixing procedures for the use of an alum as a hardener are described in Henney and Dudley's *Handbook of Photography*.[4] In practice, it is less effective and more troublesome than formaldehyde. Its problems are characterized by serious air bells and a purple-green stain formed when its violet crystals are dissolved in water.

Although various sources claim that certain spray starches will provide adequate sealing for gum printing, I have never found one that has proven workable.

N.B. Due to its highly toxic and pungent vapor formaldehyde attacks the mucous membranes of the eyes, nose and throat, causing intense irritation. It must be used in a well-ventilated room. Chrome alum and all chromium compounds are extremely dangerous. Inhaling chemical dust or contact with the skin while mixing can cause severe lung and mucous membrane damage. When mixing, do so in open air holding breath or use an inexpensive surgical filter mask. Use gloves, wear eye protection and wash dust away immediately afterwards.

Brushes:
Oil Paint Brush
Watercolor Brush

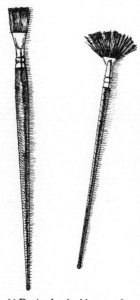

"Bright's" style spreader, fan shaped watercolor brush

Good brushes are important for the successful, smooth application of the gum bichromate emulsion. Suitable brushes are available in art stores. For beginning work, two brushes are required. In the gum bichromate process they are referred to as the "spreader" (for applying the emulsion to the paper) and the "blender" (used to blend and smooth the emulsion on the paper while also absorbing any excess). An experienced artist is able to tell the suitability of a brush by wetting and then shaping it with his fingers. However, an understanding of the various qualities of brushes is sufficient knowledge, and the exact degree of blend and absorbancy will be determined by experience.

Accounts of some early photographic processes stress that there should be no metal on the brush that may come in

contact with the chemicals. It is, however, safe to assume that metal does not interfere with the emulsion used in gum printing.

It is important to get the best quality brush you can afford since poorly made ones tend to shed hairs on the surface of the paper while coating. Both brushes are generally referred to as "Brights".[5] They are flat, sharp at the corners with a thin bristle, and a length about one and one half times their width. Fan shapes, popular for watercolor painting, although recommended by Maskell and Demachy,[6] have not proven particularly useful in comparison. The desirable brush width depends on the area of paper to be coated. For an 8" x 10" image size, brushes between ¾" and 1½" wide should prove adequate.

The standard artists- oil painting brush is useful as a spreader. Its degree of softness is not particularly important since it does not influence the appearance of the coated surface. Artists' watercolor brushes made of sable with ox-hair, squirrel hair, or ox-hair alone, have the proper degree of absorbancy and spring to be used as blending brushes. Camel hair brushes sold in photography stores for lens cleaning, although similar in softness, are too mop-like for use as either spreader or blender.

Eventually it will be felt that a greater selection of brushes varying in stiffness, point and size would be useful for manipulations in applying the emulsion and altering the image during development (a technique which is explained in the procedures of development). Select additional brushes as experience requires them. Since they are valuable tools, they must be kept clean and stored safely. Any damage can easily render them useless.

Color Pigments:
Watercolor in Tubes or Powders

Any pigment — tempera, charcoal, watercolor, etc. — may be used for gum bichromate printing provided it will dissolve in water.

Tube watercolor pigments are preferred and in comparison to powder watercolor pigments, they are easy to handle and store, and require no grinding. Mixing powders is unnecessary, particularly when the inconvenience outweighs any monetary savings. The only points I have in favor of powders are that they do not dry up as rapidly (which is of no consequence since the pigments are stored in stock solutions with gum arabic), and secondly, with certain pigments it is possible to get a greater pigment density, hence more intense color. *Greater pigment density* This latter point is more significant and I recommend some experiments with powders using a few of your favorite colors, comparing the results obtained when using tube pigment.

15

There is a large difference in quality among the watercolor pigments of various manufacturers. Only the best grade of pure, finely ground color will give satisfactory results. Windsor Newton is a recommended choice. Many other brands are not adequately ground, nor do they have adequate pigment density.

Many color effects may be obtained only by using a multiplicity of pigments. It is, however, possible to obtain a wide range even though the "palette" is fairly limited. This must be guided by an understanding of the color properties of each pigment which requires some study and practice.

Six to eight pigments would be an ample selection for starting. Some of these colors may require the addition of black or another color to increase their printing strength, as it is sometimes not possible to get sufficient density in prints with a concentration that will coat well. It may also be found that pigments containing various chemicals will often react with the sensitizer causing bleaching of the color and staining. Because the chemical varies in some pigments from manufacturer to manufacturer, and because there is a lack of general chemical data available to the public, it is difficult to recommend which colors to avoid. Choose your "palette" by favoring the earth colors, which are most highly recommended for gum printing. These, along with some variety of the basics, could include pigments such as: lampblack, alizarin crimson, burnt umber, burnt sienna, cadmium yellow

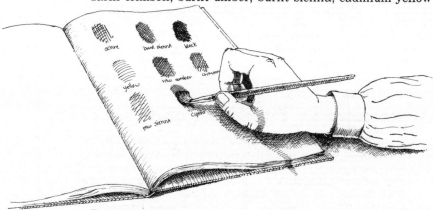

Preparing color chart

pale, prussian blue, and green. (Demachy's early gum prints were in reds and browns, and his later works in black.)

White is not used in gum bichromate printing since it is characteristic of the transparent pigment to allow the white of the paper to furnish the light areas of a picture. This is similar to the technique of pure watercolor painting that reached its perfection in England during the latter part of the eighteenth and the first half of the nineteenth centuries.

16

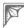

In practice, selecting the suitable color for each emulsion is difficult. Because the color charts available from manufacturers are unsuitable, as printing inks cannot accurately match the true pigment color, it is helpful to prepare your own color chart. Apply a stroke of each color to a piece of printing paper, making a wash that ranges from opaque to transparent. Carefully label it and keep it for ready-reference when printing.

Pigments may also be classified in relation to their physical characteristics. Those in standard tubes are transparent, and those designated as "gouache" have opaque color qualities. Traditionally, transparent colors have always been used, and are required for continuous tone images. The gouache colors produce strong solid colors that often remove the unique subtle characteristics of gum printing. Such considerations are important in all forms of printmaking. Every image must be carefully considered in order to select a properly representational process.

Classification and permanence of pigments

Each pigment's degree of permanence is also important. Since the watercolor pigment is all that will remain on chemically pure paper, it alone will determine the life of each print. Many manufacturers provide this information on request. A further reference is *The Artists' Handbook of Materials and Techniques,* which provides information on pigments and the Paint Standards Committee.[7]

Emulsion Binder: Gum Arabic Solution or Powder

The purpose of the gum solution is to function as an emulsion binder. The emulsion consists of the gum solution combined with a sensitizer and watercolor pigment. It is applied to the paper, exposed, and developed in plain water. The only areas remaining are those hardened by the light. The usefulness of gum arabic in the emulsion comes from its ability to remain soluble enough to permit the seepage of the still unexposed material through the tanned (exposed) surface layer. It also keeps the sensitizer from soaking in and staining.

Various other substances including gelatin, fish glue, starch, albumen and ordinary animal mucilage have historically been used for the same purpose, but due to its superior solubility, gum arabic, or "acacia," is the material to use in order to achieve the highest quality of gum print.

The best form in which to buy this chemical is in solution. It is usually available from graphic arts supply houses as it is normally used by lithographers and college print departments. The strength prepared for their need is suitable for gum printing; in addition to its convenience, the cost difference between solution and powder is minimal.

17

For a beginner, 5 liters will provide an adequate working volume for approximately 200 average size prints. The strength of this solution is measured in degree Baumé* and should be indicated on the label of the container, or if not, provided by the manufacturer. The recommended strength for gum printing ranges between 12° and 14° Baumé. It is possible to thin a heavy solution by diluting it to the required concentration — distilled water is all that needs to be added — and the strength may be tested with a Baumé hydrometer* and hydrometer jar. A gum solution thinner than 12° Baumé will not work well and requires the addition of more bulk powder.

Mixing the gum solution from a powder is inconvenient as the particles need to soak for two or three days to be absorbed by the water. Since it may sometimes be necessary to choose a powder because of the lack of a premixed solution, the procedures for mixing will be described within this text.

Mercuric Chloride
25g (for powder only)

To prevent the gum from decomposing, which can be caused by bacteria or fermentation, and becoming acidic and souring (usually indicated by a pungent odor), it is necessary to incorporate a preservative. Mercuric chloride is the chemical used for this purpose.

N.B. Mercuric chloride is extremely poisonous. Do not consume, inhale or place hands in solutions containing this or other mercury salts. Always wear rubber gloves when mixing and wash dust away immediately.

Distilled Water
5 liters (for powder only)

Because of the inconsistency of the chemical content of tap water, it is imperative to prepare the gum solution with distilled water.

Sensitizer:
Ammonium Dichromate
(250g)

Sensitizing effect of dichromate

Ammonium dichromate is the preferred chemical for the preparation of the sensitizing solution. Potassium dichromate or sodium dichromate are alternate selections but regardless of which one is used, there is no effect on the actual print quality.

The sensitizing effect is due only to the dichromate part of each chemical, referred to as the dichromate ion. The greater the concentration of these ions in solution, the greater the sensitivity of the emulsion. In a saturated solution,* ammonium dichromate has the highest concentration of this ion and has the lowest point of crystallization.*

Sodium dichromate is the next fastest printing salt but its deliquescent* quality requires some dexterity in calculating its weight since it absorbs moisture from the air at a rate fast enough to alter your calculations.

Potassium dichromate is still used by many printers. It was the first sensitizer used in the history of the gum process and is the least sensitive of the three mentioned due to lower concentration of its dichromate ions.

N.B. Ammonium dichromate and all chromium compounds are extremely dangerous. When mixing, do so in open air holding breath or use an inexpensive surgical filter mask. Always wear eye protection and wash away dust immediately afterwards.

Clearing Bath: Potassium Metabisulphite

(250g)

Once printing has been completed and the image has been allowed to harden by drying, it is necessary to "clear" or "stabilize" the print so that it will not deteriorate with time. The problem will be most visible in the form of a slight yellow stain caused by traces of the chromic salts imprisoned in the printed emulsion.

Clearing chromic salts from the emulsion

A number of chemicals are suitable for this purpose, although each has a slightly varying effect. Potassium metabisulphite is the most desirable choice. It does not alter the image color in any way, makes the dichromate extremely soluble and is itself the most soluble in water. Sodium metabisulphite and sodium bisulphite are also quite good and do not seem to noticeably alter the image. However, they are not quite as soluble as potassium metabisulphite in water and thus require a longer wash time.

Potassium alum is also usable but should be a last choice. This chemical seems to alter the image color somewhat and requires more washing than either of the other clearing agents. Its use will also cause the print to lose some of its soft, delicate effect. Some texts recommend alum. They claim it hardens the image but experience proves that the print does not require alum to be sufficiently hard.

19

White Light Source: Photoflood

Because the dichromate sensitizing ion used in the gum process is of such a low sensitivity, it is unsuitable for enlarging. A light source with an adequate output must be adapted for use with the emulsion as a contact print process.

Daylight was always the means used by early printers and when available, it obviously provides the most basic form of lighting. Today, artificial sources have the great advantage of permitting more control and are essential when natural daylight is not available.

Almost any white light* source made for photographic purposes or the photomechanical trade will be suitable. The one that is most adaptable for beginners is the 500 watt number 2 photoflood lamp. It operates at a color temperature* of about 3,400° Kelvin.[8] Either the clear or blue-colored bulbs are suitable. Some of their more significant advantages are *An inexpensive light source* that they are capable of providing an exposure in a practical length of time, are low in cost, have an adequately useful lifespan and may be used in regular household-type sockets. There is also only a minute amount of change in the quality of light throughout their use.

On the other hand, there are some disadvantages to their use. They generate a high degree of heat that with long exposures may render the unexposed areas insoluble. A fan is

Balancing exposure light using incident meter

therefore necessary to gently circulate the air above the negative while being exposed. They also require some type of reflector to contain and direct their emission, which may be purchased at a low cost from a photo supply store. They are not found to be as high as other sources in the most usable

blue-violet portion of the spectrum, to which the dichromate ion is most sensitive.

Considering the various other light sources available, sunlamps are rich in the necessary blue-violet waves but require an annoying warm-up and cooling-off period each time they are used. Fluorescent* tubes are a useful and economical light source but a bank of many lights would be required, placed about three inches away from the image. Many other industrially made light sources are more useful than photofloods, sunlamps or fluorescent tubes but their costs can make them quite impractical. If a great deal of gum printing is anticipated you might consider the advantages of something like a carbon arc.*

It will be necessary to ensure that the light source selected will provide both an even distribution and suitable intensity of illumination over the entire picture area. This must be determined by each worker on the basis of his particular printing arrangements. For initial work and certainly in the cases of small prints, you may find that one bulb or two may be adequate. The total number of bulbs used for exposure and how they are situated in relation to the paper will determine the equilibrium of light. Use an incident light* meter to check the evenness of distribution. It is usually possible to correct for any imbalance by increasing the distance between the light and print.

Even distribution of light

Should your images become larger as your work progresses, it may be necessary to construct a platform to suspend several lights.

Step One: Negative Preparation

The gum bichromate print requires exposure from a high intensity light source. This can only be accomplished through contact printing methods.

The most direct means for producing enlarged negatives involves the use of a duplicating film. With an original small format negative in an enlarger, you are able to project onto the duplicating film, producing a negative of any size.[9] This results in a negative from a negative. The film has a speed slightly slower than enlarging paper. Increases in exposure reduce negative density. A decrease in developing time reduces negative contrast.

A second method of producing an enlarged negative requires a commercially made transparency duplicator. This unit consists of a roll film camera (capable of large quantity reproduction) mounted on a copy stand with a baseboard made of opal glass. Exposures are made with the use of an electronic flash* secured below the glass.[10] Small format negatives are copied on roll film such as *Kodak Fine Grain Positive.** After processing the resultant positive, it is placed in an enlarger and projected to the required size on suitable orthochromatic sheet film.

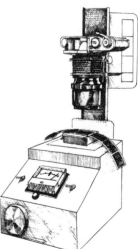

Two units currently available are the *Honeywell Repronar* made in Japan and the *Bowens Illumitran* from England. Since there are advantages and disadvantages to each unit, your selection has to be discussed with a dealer if you are considering a purchase. Home construction of a similar unit would not be difficult.

A third convenient method requires the use of a 4" x 5" enlarger. The procedure is to enlarge the small format negative to a 4" x 5" film positive. This positive is then projected in the enlarger to the required print size on orthochromatic film.

A similar method for small format enlargers would simply involve contact printing the original negative and in turn enlarging that to the required print size.

As with the production of negatives in any photographic process, density and contrast* are the most important

Slide copier for intermediate positives

aspects of quality. A literal description in text form is difficult. One early text on gum bichromate printing suggests "the negative should print on a grade two bromide enlarging paper." But, any mention of the important variables of paper manufacture or type of enlarger which would drastically vary the results of paper contrast grades is unmentponed.

Gum bichromate is a short tonal scale process. The printer should strive for full negative detail with a contrast that would be termed "flat" for enlarging purposes. And, because the sensitizer used is slow, it is important in helping to reduce exposure times that excessive negative density also be avoided.

Subjects for the gum process should not be highly detailed, but rather should have a quality similar to that obtainable by using a pinhole camera. Perhaps the early texts stated it appropriately in suggesting that the photographer should attempt to render "charm of form" as opposed to detail.

Recommended development methods to control contrast

The nature of the recommended orthochromatic and duplicating films when developed as directed by the manufacturer, give high contrast effects intended for application in the graphic arts industry. To obtain the negative quality desired for gum bichromate printing, it is necessary to use a softer developer formula. I recommend using bromide paper developer diluted 1:10 instead of the more standard dilution of 1:2. Development generally is 2½ minutes at 20°C. It may be found, using a test strip procedure, that the developer requires further alteration, but this will not be difficult to determine. Be certain to closely observe the density changes governed by exposure and the contrast changes related to development time and dilution.

Negatives of extreme contrast present a problem. Reference books and photographic product manufacturers have extensive technical recommendations available for such circumstances. The use of flashing* provides a simple and valuable answer for many contrast problems and a practical explanation is included in this text under Appendix A. Diffusion sheets * are also useful for the same purpose.

It is important that manipulations such as dodging and burning be carried out while making the enlarged negative. These corrections on the gum print itself lead to errors and are much more time consuming. The use of masking films as explained in Appendix A provides an accurate method to overcome these difficulties.

Step Two: Sizing Paper 2

The following is an abbreviated account of the procedures necessary for sizing paper. A more detailed description follows.

- Indicate the paper's back surface with a pencil.
- Mark one narrow end as the "top".
- Soak the paper for 15 minutes to 1 hour in extremely hot water.
- Hang paper to dry.
- Add 30g of gelatin per 1,000 ml cool water; soak for 15 minutes.
- Heat the container until the gelatin has dissolved.
- Soak and agitate paper in warm gelatin solution for 10 minutes.
- Hang paper to dry from "top" using clothespins.
- Store gelatin solution in refrigerator.
- Dilute 25 ml of 37% formaldehyde per 1,000 ml water.
- Agitate paper when dry in formaldehyde solution for 10 minutes.
- Hang paper to dry with clothespins from "top".
- When paper is dry, reheat gelatin to liquify it and resoak paper for 10 minutes.
- Hang paper to dry from "bottom" end.
- Discard gelatin solution.
- Resoak paper in the prepared formaldehyde solution for 10 minutes. ·
- Hang paper to dry from "bottom" end.

Some preparation is necessary to make any paper suitable for gum printing. Since the gum print is developed in water, the paper will shrink about fifteen percent the first time it is wet. In order to counter this dimensional instability and provide for multiple printing registration, it is necessary to preshrink the paper before any printing takes place. Secondly, it is necessary to provide the paper with a protective coating or size. This is to ensure that the emulsion when later applied will dry on the surface without penetrating

25

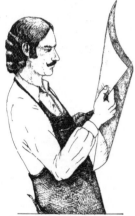

*Determining the front
of printing paper*

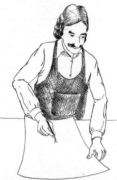

*Marking the back sur-
face*

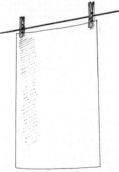

*Suspending the paper
to dry*

and staining the support. To help overcome the frustration
of sizing paper, prepare the largest quantity that is possible
to manage at one time. Also, avoid tearing the paper into
smaller pieces unless necessary to accomodate the soaking
tray that will be used.

First, determine the front and back surfaces of the paper,
regardless of their similarity. Some papers may be used on
both sides equally well, but many are finished only on one
side; the reverse may contain a different grain, irregular
spots, flaws, and blemishes which do not show up until
printed upon. The distinction may be made by observing a
number of varying characteristics, and will be easier before
any sizing takes place.

The most visible feature almost always provided is known
as a watermark. This is the manufacturer's identifying label
indelibly stamped in the substance of a sheet of paper
during manufacture. It usually bears the name of the com-
pany and particular brand of paper. Because the watermark
is embossed within the paper's surface, it is most visible
when viewed by transmitted light. This label will present
itself as readable when the paper is viewed from the front.

The front surface may often be found to be both smoother
and brighter than the back. Also, if an edge has been
factory deckled, it will always bevel up to the front surface.

Once determined, mark the back lightly with pencil and
indicate one end as being the "top."

The next step is to shrink the paper, which involves
thoroughly soaking it in water and allowing it to dry before
any printing takes place. I recommend soaking from fifteen
minutes to an hour, using the hottest temperature of water
your hands are capable of working in. It is more common to
soak the paper for a shorter time and at a lower temperature
but my directions are based on what I consider to be criteria
for a "full" development. The development procedure for
gum printing involves soaking the print in plain tap water.
A great deal of control during development is possible by
temperature variation, using either cool, warm, or hot water
and by altering the total development time. Because of these
variables it is important that the presoaking time be equal
to the development time, at a temperature that will prevent
the dimensions from altering during the later stages of the
printing process.

Fortunately, at this stage of the work it is not necessary to
wait attentively once the procedure has begun, but only to
occasionally agitate the paper by pulling the bottom sheet
free and laying it on the top. Upon completion of presoak-
ing, remove the paper from the water for drying. Spring-
type wooden clothespins strung on a length of cord is the
most practical drying arrangement. Clip the paper by the
corners with the narrow end at the top and leave hanging
until dry.

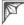

If you have a large darkroom sink, it is a good idea to suspend the drying line above it so that any water and sizing liquids will be prevented from contaminating the darkroom floor.

It is not sufficient to size the paper, as many older texts recommend, by coating the front using a brush or sponge. It requires less time and is more thorough to prepare an adequate amount of size to fully submerge the paper. Use a tray large enough to handle the paper and rinse it with hot water just before use to prevent cooling of the sizing solution.

To prepare the gelatin sizing solution, dissolve 30 g of gelatin per 1,000 ml cool water. (If warm water is used, lumps will form that impede the gelatin from dissolving.) Soak the gelatin for fifteen minutes in the cool water, then heat until it is completely dissolved. Pour the hot gelatin *Soaking in the sizing* into a large tray, insert the paper and begin to agitate by *solution* removing one sheet at a time from the bottom of the tray and reinserting it at the top. Bring the center of each sheet in contact with the solution first and then allow the sides to fall.

After a soaking of ten minutes begin to remove the paper by drawing each sheet separately over the edge of the tray. Doing the back side first and without reimmersing it, invert and draw it out over the front, assuring all air bubbles are eliminated. Dabbing any existing bells with a sponge is also helpful. Be careful when handling the dampened sheet as it can buckle, causing a wrinkle that will show when the

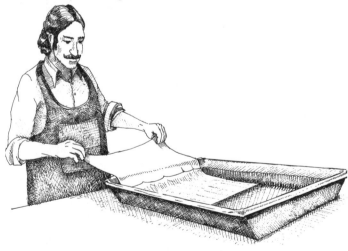

Removing air-bells

paper dries. Hang each sheet to dry using the clothespins, suspending it from the narrow edge marked "top."

27

Since a second coat of size will be needed, store the gelatin solution in the refrigerator between coats. It will gel but may be liquified with heat and used for the second application once the paper has dried.

Application of second
sizing; hardening
Before applying the second coat of gelatin, in a well-ventilated room prepare a hardening bath by mixing 25ml of 37% formaldehyde per 1,000ml of water. Soak the paper in this solution for ten minutes, interleaving the sheets regularly as described for the gelatin procedure. Then, in a similar manner, remove and suspend each sheet to dry from the end marked top. Store the formaldehyde solution. When the sheets have dried, resoak them in the hot gelatin solution for another ten minutes and suspend them to dry from the bottom end. Discard the gelatin following this second coating. A second soaking in the formaldehyde solution should now take place.

It is always better to use two successive baths of formaldehyde than one, since a stronger dilution of gelatin often gives irregular or spotty results and a stronger dilution of formaldehyde has a tendency to make the paper susceptible to cracking when dry. Also, mixing the formaldehyde with the gelatin does not provide good sizing results.

Once the sizing is complete, the paper is stored in a convenient container—preferably one that does not contaminate its acid-free contents.

Step Three: Preparing Sensitizer 3

Formula: Ammonium Dichromate 29g
 Water 52° C. 75ml
 Cool water to make 100 ml

The saturation of dichromate in this formula has no effect on the quality of the print but does alter the sensitivity or speed of the emulsion. The greater the volume of dichromate, the more exposure sensitivity will increase. My formula suggests a saturated solution* and exposure will be the

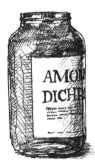

Weighing sensitizer

shortest when used as directed. The amount of dichromate required to make a saturated solution depends on the temperature of the solution. This formula is saturated at 16°C. When kept and used near 20°C as the photographic standard, it will be constant in strength. To eliminate variables, this formula should remain constant.

If the prepared sensitizer should chill during storage, crystals will form and separate out. Simply reheat until it is once again thoroughly dissolved.

29

Step Four: Preparing Gum Arabic Solution

4

As recommended in the materials list, powdered gum arabic should only be used if it is impossible to locate it in a premixed liquid form. The use of the following formula will yield a dilution of 12.5° Baumé, if powder preparation is necessary:

Mercuric chloride	2.5g
Water (cool, distilled)	1,000ml
Powdered gum arabic	300g

At a strength between 12° and 14° Baumé, the gum solution does not set rapidly, making it possible to apply and blend the gum on the paper before it starts to dry. Check the strength of this dilution with your Baumé hydrometer and hydrometer jar. Since many hydrometers are calibrated in units of specific gravity, it is useful to know that 13.18° Baume is equivalent to 1.10 on the specific gravity scale.

For mixing the powder, use a wide mouth mason jar. Never mix gum arabic with hot water as this causes changes in the chemical composition and a lowering of its solubility.

The mercuric chloride acts as a preservative to prevent bacterial growth in the gum solution. A sour gum solution can work as well as a fresh one but differently—the continuing, progressive souring will alter print consistency. A gum solution mixed with mercuric chloride has been known to stay fresh up to eighteen years.[11] Mercuric chloride will readily dissolve in water and presents no special mixing difficulty. Simply stir it up in the distilled water before attempting to dissolve the gum arabic powder.

If gum arabic chunks are used instead of powder, it is possible to speed up the dissolving process by rubbing the chunks in a mortar, adding small portions of water. Filter the mixed solution through a piece of fabric to ensure uniformity.

Wide mouth mason jar

Low-grade gum arabic is light tan in color; top-grade pharmaceutical gum contains very little tannin, which is responsible for the brown color, and it is almost white to pale straw yellow.

Protect the mixed solution from heat and sunlight.

Step Five: Preparing Stock Pigment and Gum Solution

5

The light sensitive emulsion used in gum printing is a combination of gum arabic, watercolor pigment and dichromate sensitizer. To gain in convenience and accuracy, it is best to prepare a stock solution of the pigment and gum that will be ready to mix with the dichromate when required.

Tube Pigments

Determine the amount of gum solution to add to the total amount of pigment in each tube beginning with the proportion of 1g of tube pigment per 12ml of prepared gum solution for all colors.[12] Accurately measure the required amount of gum into the cylindrical graduate, then pour the gum onto the pigment and mix well with a glass pestle. If a pestle is unavailable, almost any grinder will do for tube colors—a palette knife or even a brush with short stiff hairs. Pour the

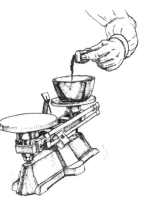

Weighing pigment

Measuring gum solution *Drawing out the gum-pigment solution*

ground solution into one of the squeeze-drop plastic containers, using a stiff bristle brush to force any remaining solution out. On the container, label the color, its mixed dilution and the date.

33

Powder Pigments

These are prepared in the same manner as tube colors, except for the addition of a plasticizer.* (For a more detailed explanation, consult *The Artist's Handbook* by Ralph Mayer.) Prepare and label a stock solution of this from the following formula:

40g of white sugar in 20ml of hot, distilled water
150ml of stock gum solution
10 drops of Photo Flo
30ml of glycerol

Determine the amount of gum solution to add to the total amount of pigment in each jar beginning with the proportion of 1g of dry powder pigment per 25ml of gum solution for all colors.[13] Before blending the pigment and gum, work the powder up to a paste using about 3 or 4ml of the plasticizer per 4g of dry powder. Then, pour the measured amount of gum onto the pigment and mix well with the glass pestle. Thorough grinding is essential. Manipulate until every particle has become completely dissolved into the medium. Once prepared, label each color in the same manner as directed under tube pigments.

Special mixing circumstances arise with the use of charcoal as pigment. H.G. Abbott states in *Modern Printing Processes:*

As a rule, charcoal does not mix readily with the gum and water, and should be first ground into the gum and the mass thinned afterwards with water to the right consistency. Too much grinding will be ruinous to the identity of the substance and we might just as well use black paint. The best way to use charcoal is to first sift it through bolting cloth or a fine sieve and then work it thoroughly into the gum as explained above.[14]

Varied intensity of pigments

It is found that many pigments used in printing are more intense than others. This makes it impossible to provide any absolute rule for the proper amount of stock gum solution to use with the pigment. The formula provides a useful working ratio, although pigment requirements often range from 5 to 10g pigment per 100ml of stock gum solution for tube pigments and from 2 to 6g pigment per 100ml of stock gum solution for powder pigments. To use a testing procedure for each color when beginning is not at all necessary but could be considered as your methods improve. A good description for determining a "correct" ratio of pigment to gum solution is found in Henney and Dudley's *Handbook of Photography:*

As the longest scale of gradation is secured when the coating mixture contains the largest possible amount

of pigment and as a long scale is usually desired, it follows that the coating mixture should hold as much of the pigment as can satisfactorily be used. But for every paper, every pigment, and every gum solution there is a maximum relation of pigment to gum which can be used without staining the paper—or rather, to be precise, there are two such maxima, one for automatic development, the other for brush development. The method of determining these maxima is as follows:

Squeeze into small mortar an inch length of the pigment, and rub this up with ½ dram of the gum solution. With a fine brush dipped into the mixture, make a small mark on the paper which is to be used, and opposite this mark, pencil "1 in. to ½ dram." Add ½ dram of gum solution to the mixture, rub it up well, and make another mark, labeling this "1 in. to 1 dram." Add another ½ dram of the gum solution, and label the resulting mark "1 in. to 1½ drams." Continue this until a series of marks extending to "1 in. to 10 drams" is reached. Then allow these gum-pigment marks to dry thoroughly, and let the paper float face down in a tray of water at room temperature for ½ hr. On inspection it will be found that some of the marks have entirely disappeared, while others remain visible. Suppose, for example, that the last visible mark is opposite the notation "1 in. to 4½ drams"; then it is known that, if pure whites are to be secured with automatic development, the maximum proportion of pigment to gum solution in the coating mixture must be 1 in. to 5 drams. Now with a soft camel's-hair brush, brush over the remaining marks, when it will be found that others will disappear. As an example, suppose that the last one visible after this brushing is opposite the label "1 in. to 2 drams"; then it is known that, if brush development is to be used and pure whites are to be obtained, the maximum allowable proportion of pigment to gum is 1 in. to 2½ drams. If a note is made of these proportions, it will be possible at any future time to predict accurately the maximum gum-pigment relationship for that pigment and that paper. This should be done for the various pigments which are to be used and for the various papers. A table can then be drawn up giving the sundry relationships at a glance, thus avoiding the "by-guess-and-by-gosh" method so common in gum printing.

This method serves also to indicate the possible maximum when two or more pigments are mixed to secure variations in color. Thus, if it has been determined that a certain black requires 5 drams of gum

Predetermining proper pigment density

solution to 1 in. of pigment for automatic development and burnt umber requires 4 drams to 1 in., then, if it is desired to mix the pigments in the proportion of 2 to 1, it follows that the worker will use 1 in. of the black, ½ in. of the burnt umber, and 7 drams of the gum solution.

Note that no sensitizer is used in these determinations.

It may seem that this method of determination involves a great deal of work but actually the labor is not excessive, and, if the experiments indicated are carried out and the suggested table is drawn up, a vast amount of effort and disappointment will in the long run be saved.[15]

Avoiding excessive pigment　　In printing, excessive pigment is characterized by an over-all stain, degrading whites or a grainy "flake like" appearance. It is possible by strengthening the gum solution outlined in Step Four to support more pigment in order to expand the print's tonal scale—the technique used by one-coat printers. However, a strong gum solution is difficult to coat and blend and is not adaptable to multiple printing. Alternately, a weak gum solution will hold only enough pigment for weak coats and stays wet on the paper so long when coating, it most often stains by soaking into the sizing. It is best not to alter the gum solution at all, and to use it as suggested in Step Four.

Step Six:
Preparing Paper for Printing

6

It is best to sensitize the paper immediately once the emulsion is mixed. To facilitate this, some preparation is required.

If the paper has not yet been torn to the required size, do so at this time. Be certain to allow for a suitable border around each image.

Positioning negative using a see-through plastic ruler

Place the enlarged negative on the paper in the exact position desired for the final print. For accurate placement, I have found the use of a "see-through" plastic ruler an indispensable tool. The type that is measured in equal increments from the center going out in both directions—horizontally and vertically—facilitates precise centering.

Once the negative is positioned, secure it with a small piece of masking tape. Next, tiny pinholes are made, pierc-

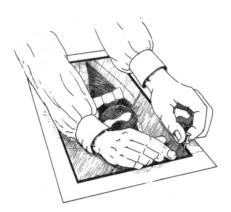

Pin-hole registration

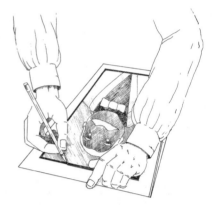

Tracing the negative area

ing both the negative and paper in two corners.[16] These pinholes serve as a guide for multiple printing. Registration is most accurate when the two points used are as distant as possible.

Keeping the negative registered, lightly trace its outline in pencil to indicate the area of surface on the paper to be coated with emulsion.

Step Seven: Preparing the Emulsion

7

Formula: 1 part prepared ammonium dichromate
(2.5ml per 8" x 10" print)

1 part prepared pigment and gum
(2.5ml per 8" x 10" print)

Select the color of stock gum-pigment solution and shake thoroughly to ensure a uniform solution[17] If the pigment is used only periodically, remove the lid and stir up any settled particles.

Measure the required amount of gum pigment into the cylindrical measuring vial. Gauge the measurement to the bottom of the meniscus* as closely as possible—even though estimation is necessary because of the opaqueness of the solution. It is recommended to mix an excess of emulsion for use since running short when the paper is only half-coated can ruin the paper. Should such a problem occur, promptly wash the emulsion away in running water.

Carefully add to the gum pigment solution an equal volume of ammonium dichromate sensitizing solution.[18] Use

Wearing rubber glove, blend the emulsion by shaking

the same measuring cylinder (without having poured out the gum pigment) to eliminate the error which may be caused in the drainage of the tacky gum solution. The

39

emulsion immediately takes on a greenish color from the dichromate but this will later disappear during development.

Thoroughly blend by shaking what is now the emulsion and pour it into a wide-mouth bowl in preparation for coating the paper. The mixed emulsion does not store. It must be applied to the paper immediately because it soon begins to harden and deteriorate, becoming a darkened gel.

Commence your working method for the emulsion with this standard dilution of 1 part ammonium dichromate to 1 part of gum pigment. Should you later wish to alter some of the possible variables, a number of observations will become obvious:

1. Increasing the amount of pigment gives a broader tonal range but degrades the whites and often produces a stain in the paper. Reducing the pigment subdues the tinting strength of the emulsion.

2. Increasing the amount of gum in the emulsion makes the solution difficult to coat. It also gives a higher contrast image and frequently causes the emulsion to flake off during development. Reducing the amount of gum usually causes the emulsion to stain the paper—the pigment becoming so firmly embedded in the paper's fiber it prevents proper clearing of the highlights by ordinary development.

3. Increasing the amount of sensitizer increases the speed of the paper but decreases the print's contrast, producing flat, lifeless prints. Reducing the amount of sensitizer makes the emulsion too adhesive and it becomes difficult to apply.

Classic preparation of emulsion

An informative account of the emulsion preparation methods of Maskell and Demachy is given in *Nonsilver Printing Processes:*

> It would be possible to give a formula for the quantity of bichromate to be added to the mixture of pigment and gum, if the proportions of pigment were in every case constant. But they are not, for great depth of colour can be got with a small portion, say, of red chalk or lampblack, whilst a far greater bulk of colour is needed with the sepias, Van Dyck brown, bistre, or umber. On the other hand, there is a standard degree of thickness necessary for rapid and even coating. It follows therefore, that more bichromate has to be added to a sepia mixture to dilute it to proper fluidity than would be required for lampblack, because the smaller bulk used of the latter gives a much thinner consistency. Only repeated trials can teach the beginner what degree of thickness will allow an even coating. As a guide, let him begin with common red ochre, and taking equal parts of gum and bichromate, say, one drachm of each, use with this forty grains of

the pigment. A trial coating may then be made on a sheet of paper, and according to the conduct of the mixture under the strokes of the brush we can judge whether the proportions are correct or whether either gum or bichromate should be added to thicken or dilute the consistency.[19]

W.J. Warren, in *The Gum Bichromate Process,* gives further indications of the flexibility inherent in the process:

I may say that M. Demachy uses moist colours, and mixes his sensitising solution with the paint and gum solution, coating all together. In the lecture which he wrote for the R.P.S., and which was read before that society in March 1898, he stated: "With regard to the strength of the gum solution I prefer to make my solution by adding two parts of cold water to one part of gum. Measuring by the eye only. Filter the gum through a square of muslin twenty-four hours after, and test it with a hydrometer—18° to 20° seems to be the proper thickness...The supply of gum must be sufficient to act as a sort of supplementary size, preventing the pigment from sinking into the fibre of the paper. A certain depth of colour is necessary to produce an artistic effect, and it varies according to the subject, the bulk of pigment changing also according to its colouring power. Finally, the operation of coating can only be successfully performed when the mixture is fluid enough to be evenly spread, and thick enough to set rapidly and form a continuous and homogeneous film before it has time to stain the underlying paper. I never measure my gum or bichromate solutions, neither do I weigh my pigments. I let myself be guided by the depth of colour, the feel of the mixture under the brush, and the way it spreads on trying it on a bit of waste paper.[20]

Demachy on mixing the solution

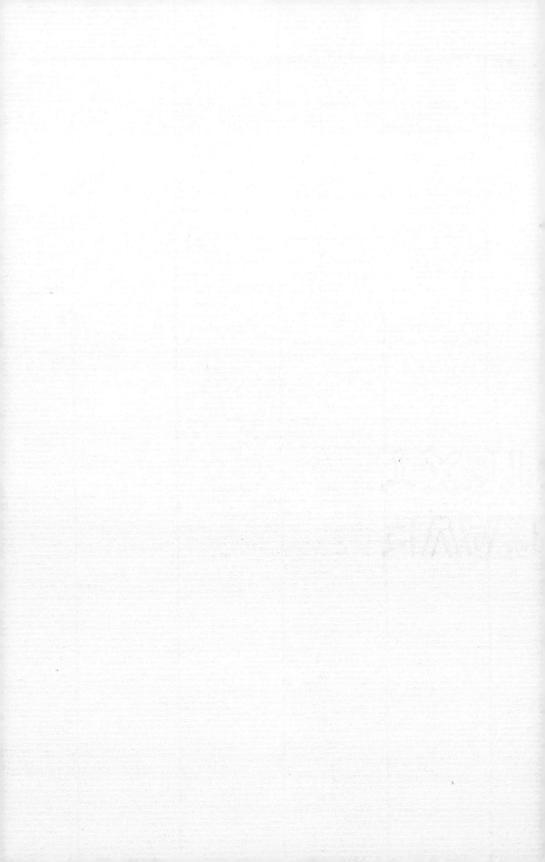

Step Eight: Coating the Emulsion on Paper 8

For practical purposes the emulsion may be thought of as insensitive to light until it has dried. Dimmed room illumination should be used for the actual paper coating operation. Darkroom safelights containing fifteen to twenty-five watt bulbs normally positioned with the filters removed provide both a safe and workable light level.

The emulsion may be successfully applied to dry paper, or the sheets may first be soaked in water and blotted with newsprint just prior to application. The choice of method must be determined by the image qualities, because dry paper is capable of subtle-to-distinct brush marks, while moist paper is useful for a smooth air-brush finish.

Before applying the emulsion, secure the paper with pushpins or tape to prevent movement, and have on hand both the spreading and blending brushes. Before use, wet both brushes and squeeze out any surplus water. This will ensure a more even coating that would be obtainable using dry brushes.

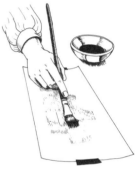

Commencing emulsion application using vertical strokes

Dip the spreading brush in the emulsion, draw it out over the edge of the bowl to remove any excess and begin coating the area earlier designated by pencil. Use light rapid strokes drawing vertically across the full image area, then horizontally covering the sheet as quickly as possible.

Next, moisten the blending brush with the coating solution, squeeze out any excess and immediately begin blending the coat until smooth.[21] Frequently remove the excess from the blender by drawing the brush over the edge of the coating bowl. Many of the brush marks that are visible at this time will disappear when dry (a little experience will indicate when it is being properly applied while the emulsion is still in the wet state).

Blending the emulsion on the surface of the paper is crucial, since it rapidly sets during the act of brushing. Success in achieving a wide tonal range on the print is dependent upon achieving a thin coating of the gum-pigment-dichromate emulsion. If the coating is too thick light may not penetrate the highlights and midtones, caus-

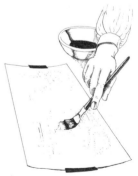

Switching to horizontal strokes to fully blend emulsion

ing them to dissolve during development. A coating that sets too rapidly when applied can be corrected by the addition of more gum arabic to the stock gum pigment solution. This would necessitate altering the formula discussed in Step 5. Diluting the emulsion with more sensitizer will also correct a coating that sets too rapidly but it will weaken the gum and frequently cause stains or flaking off during development. It is recommended to keep the ratio of stock gum pigment solution to sensitizer the same as suggested in Step 7.

A properly coated emulsion will not run. This enables suspending the sheets to dry using clothes pins in the same manner as for sizing. In normal room conditions drying will take fifteen minutes. Drying time may be accelerated by directing a fan to gently blow on the emulsion surface. Heat must not be used as the emulsion would be rendered insoluble. The paper will be slightly curled while damp but flattens when dry, with the emulsion taking on a matt appearance.

Once the paper has dried, it should be exposed as soon as possible. If desired, storage for short periods of time without staining or a loss in sensitivity is possible. Demachy and Maskell claim that they have used paper as much as eight days after coating.[22] Intentionally storing coated paper beyond 24 hours will only lead to inconsistency and variations in the emulsion. It is important that the brushes be immediately placed in water to soak once the coating has been completed until it is possible to thoroughly wash them. If the emulsion should harden on them before washing, they can easily be ruined.

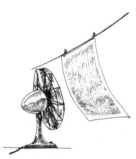

Fanning emulsion to hasten drying

Note on Presensitizing and Storing of Paper:

This is a topic which is usually discussed when the coating methods of gum printing are being considered. Maskell and Demachy present the principles with a favorable attitude in this description:

> It consists in sensitising the paper in the first place and then applying the gum and colour, instead of coating with a mixture of gum, colour, and sensitising agents. Very simple indeed—as simple a matter as the balancing of Columbus' egg—but we think that it has not been noted before, or at any rate published with regard to any form of carbon printing.
>
> The paper, then, is to be first of all soaked in a ten percent solution of bichromate of potash for about two minutes, rocking the dish the while, to avoid air bubbles. It is then dried (bone dry), and is ready for coating in the manner previously described, the coat-

ing mixture consisting of gum at twenty percent, and a sufficiency of colour. We reduce the strength of the gum by one-half because it is not now so reduced by the bichromate solution.

The sensitiveness of the paper is increased to an enormous extent. Instead of being, as in the earlier system, three or four times slower than chloride or platinum paper, it is now quite as rapid as either, or as ordinary carbon tissue: even more sensitive perhaps. Unexposed, the film dissolves and leaves the paper pure, so that the edges of a print protected by the rebates of the frame are quite white, and the highlights of the picture, also, are more amenable to control. This is especially marked with black and brown pigments, which formerly were very apt to stain.

The argument for pre-sensitizing paper

The rationale of this system would appear to be that each molecule of the pigmented gum with which the dried bichromate paper is coated absorbs, or is in contact with, just its molecule of bichromate and no more. The rest of the bichromate, protected by the coating of colour, is probably very little acted upon.

In our earliest essays on the newer system we found that the images were apt to be hard; the highlights dissolved away too quickly and cleanly. This, however, clearly resulted from wrong proportions of the materials used, and so again, as we laid down in a preceding chapter, we shall not attempt to give an empirical formula. A very little patience and practice will teach each worker what is best for his own requirements.

The general practice is, we think, rendered more easy. We may now sensitise as many sheets of paper as we like in advance, we can keep our colours mixed with water in any quantity, and have only to add, as required, in equal proportions, gum solution of the desired strength (i.e., at about 40 percent.). There is in this way also, far less waste. The results appear to be much more certain, and if we remember how very sensitive the film is and that where formerly, perhaps, four actinometer tints were required, less than one will suffice, failures will not so often occur.[23]

I am not in agreement with the enthusiasm for presensitizing as described in this outline.

Contrary to their statements, it should be mentioned that the extent to which the sensitivity is increased is not a significant amount. This is because the ammonium sensitizer commonly used today is faster than the potassium ion then used, and the high intensity of modern artificial light sources permits exposures in reasonably short times.

45

Disadvantages of pre-sensitizing

The highlights are fully amenable to control with the standard methods used whether the paper has been presensitized and stored or not. With a properly sized paper, there is no problem with any pigment staining.

The sensitizing of many sheets in advance is of no benefit, since the sensitized material will deteriorate in a relatively short time, altering the speed and clearing quality of the sensitizer.

Their statement "colors may be kept mixed with water in any quantity and have only to add gum solution of the desired strength," is of no consequence because it is not superior to the method outlined in Steps Five and Six in this text.

There may be slightly less gum pigment solution waste in coating after the sensitizer has been applied, but the waste is not a significant amount for concern.

I find that their methods of presensitizing are more time consuming for both single and multiple printing, since two drying operations are then necessary. It also becomes impossible to presoak and blot the paper to obtain the smooth, even coating described earlier in this step.

The following statements from *Modern Print Processes* may further assist your opinion on this matter:

> The process is worked out in two different ways but the results are identical. The paper may be coated with a mixture of gum, pigment, and bichromate, or the paper may first be sensitized with the bichromate and a mixture of gum and pigment applied over it.[24]

> Sensitized paper, if kept between blotters or in a book in the dark will keep for about six weeks, so that a supply of paper can be sensitized in one evening which will last for a month.[25]

> So long as the sensitized surface presents a brilliant yellow color, as it had when packed away, it is in good condition, but when the color has changed to a dirty green-brown, the paper is no longer fit for use.[26]

Step Nine: Exposure

9

Re-register the negative on the paper using the pinholes as outlined in Step Six. Lightly press a few small pieces of masking tape around the negative's perimeter, securing it to the paper to prevent any movement. Place the negative and paper in the contact frame and position it for exposure below the exposure light.

Exposures are best determined by intuition, based on each negative, the light source, and of course, the result desired. Although the image will become faintly visible during exposure, this still does not provide for an adequate assessment of the "correct" exposure time. Earlier in the history of this process, actinometers were widely used to gauge exposure. These were a form of print meter that exposed a piece of sensitized printing-out paper (p.o.p.) to light until it darkened to a standard tint. The time it took to reach this tint was measured by a stop watch and a calculator converted this time into the correct exposure for any type of sensitized material. Although they were suitable for slow sensitive products of the early days, they have now become obsolete with the invention of the photo-electric cell.

Until a proper "sense" has been acquired for the emulsion sensitivity, a test strip method is required.

The use of test strips

The exposures for gum printing vary widely, but a test ranging from two to fifteen minutes usually provides an adequate indication for the correct exposure. Because of the wide exposure latitude and the highly manipulative potentials of the development process, few exposure tests will be required once the controls are understood. The attractive results which may be had from degrees of both over- and under-exposure, combined with manipulation in development are unique advantages of gum printing.

The color of the pigment being used bears no significance on the sensitivity of the emulsion.

Step Ten: Development 10

Once the print has been exposed, development should follow immediately. Even a short delay may lead to overexposure by a "continuing action" of the hardening that occurs within the exposed areas of the print.

Development is a reductive process using plain water. Prepare at least one tray more than the total number of

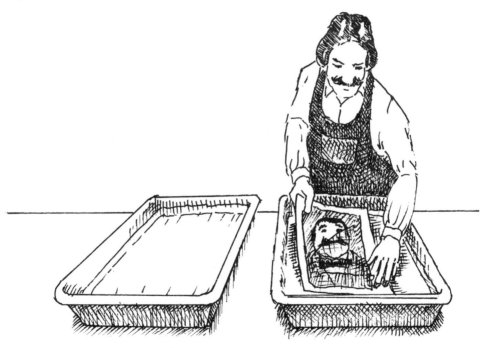

Immersing exposed print face up.

prints that will be handled and keep only one print to each tray. The print should be gently inserted with the emulsion side up. The emulsion becomes insensitive once it has been

Inverting print in U shape

Reduction of overexposure

placed in water and therefore the print may be developed under normal room illumination.

The wet emulsion is extremely soft and delicate. Any agitation of the development water will only produce an uneven development and must be avoided. The unexposed gum will begin to dissolve immediately. Within a minute the print should be gently removed and carefully lowered, emulsion down, in a "U" shape, into the second tray. Let the center come in contact with the water first. Then slowly lower the corners to avoid air bubbles. The unexposed emulsion will continue to dissolve, floating to the bottom of the tray. If the print were permitted to develop face up, the sensitizer and pigment would settle on the surface causing a stain.

As the water in the tray becomes heavy with the color of the dichromate-pigment, transfer the print back to the first tray, which should have been refilled with clean water during the interim. The time allowed in each tray may increase as the deposits of emulsion given off become less and less.

Although the emulsion that was not hardened by exposure is soluble in water at any temperature, it is possible to speed up the process by altering its temperature—from cool to warm or hot. The total time required for development varies between fifteen minutes and one hour, depending on the original exposure, water temperature, number of tray changes and the results desired. Development must never be so short that the emulsion tends to "run" while hanging to dry.

Prints that may appear either over- or under-exposed during development should not be discarded. A useful technique of reducing over-exposure is to add a few drops of ammonia or other alkali to the development water. The quantity must be small: 15ml of anhydrous sodium carbonate to 2 liters of water will have a noticeable effect. Any excess may alter the paper dimensions, causing an error in the pinhole registration. An under-exposed print may be corrected in the stages of multiple printing described in Step Eleven. It is also possible to remove the underexposed print from the developing water before the highlights wash out completely, placing it face up on a piece of blotting paper inclined at a slight angle so that the water may drain away. If the print is allowed to partially dry it may then be developed with a brush or water spray, because the pigment in the highlights will then be firm and more resistant to development.

One of the unique qualities of gum printing is that because of the softness of the emulsion coating during development, it is possible to manipulate the image. Try using a series of different brushes ranging in hardness and width, to lighten highlights or remove other areas of the image. If

the brushwork is applied to the print while submerged in water, the effect will be very delicate. Out of the water, brush marks will be more pronounced.

Begin by removing or "erasing" pigment in selected areas, and further produce a brush stroke quality throughout the image. Color and detail may be fully removed from

The use of brushes during development

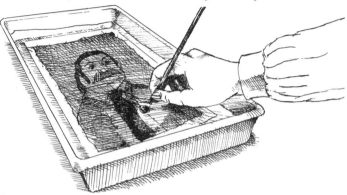

Development manipulation

an area and replaced by exposure with an emulsion of an alternate color. Water may be used for an interesting pebbling—by applying a direct flow that either gently or forcibly strikes the surface. Small quantities of fine sand put in the developing water to gently abrade the print can also be effective. In the case of overexposure, early texts go so far as to recommend rubbing sawdust throughout the print. One technique that was used by Demachy involved putting glycerine over the print once exposure was complete—just prior to development to soften the effects of the brush strokes.[27]

As your experience broadens, new and personal methods will produce striking results in the development stage. This potential extends gum printing far beyond the level of any mechanical process and should be utilized to achieve the full benefits of this printing process.

Manipulations during development should not be undertaken until the development time is at least one half complete, in order to have an accurate indication of the exposure on the print.

Once the paper has reached the desired degree of development, it is to be gently removed from the water and hung by the corners with clothespins to dry. After a few minutes of setting, the drying process may be speeded up by directing a fan to gently blow on the print.

This first exposed emulsion provides the base for a gum print.

Step Eleven: Multiple Printing 11

In testing the gum bichromate emulsion, you will find that it is possible to render the tonal scale of a suitable negative and emulsion in one printing.[28] This procedure, however, does not exploit the complete range of tones possible, nor the potentials of multiple printing. Multiple printing involves building additional layers of pigment on the print by repeating the steps of the process: the entire paper coating, negative registration, exposure and development—manipulating any of the potential variables where desired. Henney and Dudley's *Handbook of Photography* provides an informative account of the possibilities of multiple printing:

Exploiting the full range of gum printing potential

> One reason that so many beginners in gum work get into trouble is that they expect the first printing from the negative to look like a print and try to make it do so. It should not; it should look like a very sick imitation of a print—pale, washed out, very likely no more than a flat tone in the shadows, and in general thoroughly unsatisfactory. It is astonishing to an inexperienced worker to see how the print assumes vigor and character with the addition of subsequent printings.
>
> If the negative is soft enough so that its entire range of gradations is rendered in one printing of gum, then when the print has been developed and dried it may be coated a second time and printed again, for the same printing time, and developed as at first. Thus the second and subsequent printings are used merely to add depth and contrast. It is much more likely, however, that the scale of the negative will be too great to render in one printing of gum, in which case the shadows—perhaps even the halftones—of the first printing will be merely a flat tone and must be brought out by the later printings. The coating mixture may, perhaps, be the same as for the first printing but the printing time less, e.g., if the

negative requires three printings to render its full scale, the first one may be timed for four minutes, the second for two, and the third for one, each printing being developed fully. Some workers have been known to use sixteen or seventeen printings, and the writer knows of one who went to twenty-five, but this is sheer frivolity. Using a well-sized paper, which permits the use of a fairly large amount of pigment, the utmost richness and depth of blacks can be got in five printings, and the scale of practically any negative can be rendered in six or eight printings.

It will be apparent that very great variations in coating and printing are possible in order to secure various effects. Thus a long scale may be secured with little depth of shadow by using a relatively small amount of pigment in the coating mixture; or the shadows may be emphasized by using light doses of pigment for the high-light and halftone printings, with a heavy amount, printed lightly, for the shadows. Each worker will think up these variations for himself, but it cannot be too strongly urged that he keep a record of what he has done in each case. If he fails to do this he will not know where he is; he will be unable either to duplicate or to predict results, and he is likely to abandon gum printing under the impression that it is too difficult. As a matter of fact, gum printing is not at all difficult, but it does demand care and accuracy. Given these and a moderate amount of experience, gum printing will be found not only much easier than bromoil or even than plain bromide enlarging, but far more satisfactory in its results.[29]

Exposures for highlights, midtones and shadow areas

The theme of this guideline and most others written on the procedures seems to center primarily on "adding depth and contrast" to the image. The method of making the print with three coatings—one each for the highlights, midtones and shadows, reducing the exposure for each one and also frequently decreasing the pigment density, is the most common approach.

A guideline with indications for a specific emulsion formula is given in Neblette's *Photographic Principles and Practice:*

The actual mixture used for coating varies with the paper and the negative and also with the effect desired. Practically every worker develops a different formula after practice and while there may be little difference, yet it is better adapted to his own personal methods of working.

However, the following formulas are given for the benefit of the beginner:[30]

54

Shadow Coating

Gum solution 15 c.c. ½ oz.
Sensitizer 15 c.c. ½ oz.
Ivory black from tube 4 in. 4 in.

If the negative has a short scale of gradation it may *Suggestions for in-*
be possible to use the above for all the printings; if, *creasing gradation*
however, this is not the case and the negative has a long
scale of gradation and prints well with bromide or
platinum, then it will be necessary to vary the coating
mixture so as to secure a longer scale. It is generally
necessary to make three printings: one for the shadows,
another for the halftones and finally one for the high-
lights. The following are advised for the halftone and
highlight coating mixtures.

Halftone Coating Mixture

Gum solution 15 c.c. ½ oz.
Sensitizer 15 c.c. ½ oz.
Ivory black from tube 2 in. 2 in.

Highlight Coating Mixture

Gum solution 15 gm. ½ oz.
Sensitizer 17.75 c.c. 5 dr.
Ivory black from tube 1 in. 1 in.

Their comments seem to be directed toward producing the
proper gradations of a continuous tone image; it is possible to
discover methods more flexible than they indicate. There is no
mention in either of these descriptions of burning-in pigment
and brush developing for intentional "flaking," totally vary-
ing the choice of color or perhaps attempting to selectively
color small areas of the image. In fact, the potentials are so
vast that we are without any definition or scientific approach
to what may be done. The worker's direction must be deter-
mined by as much trial and error as possible. Some of the
following comments and suggestions may be useful.

Another emulsion may be applied as soon as the print has
dried following development, or at some later convenient time.
How long the print is able to remain stable without being
"cleared" as explained in Step Thirteen has never been fully
clarified. I have stored prints without noticeable deterioration
for up to one year.

It is obvious that the time involved in the coating, printing
and development of one gum print is considerable. Testing
several different negatives at the same time or making several
prints from the same negative by coating three or four sheets
of paper are good ways to increase productivity. The second,
third and fourth sheets, with variations in emulsion, can be
given varying exposures while each previous sheet is develop-

55

ing. Because three to eight printings are frequently necessary for many images, you need to acquire a different mental attitude and appreciation for working on prints over an extended period of time.

Prints showing initial coatings with obvious faults such as streaks, blemishes or slight irregularities are still suitable for further work. The methods used in multiple printing often eliminate errors or alter them to impressive effects.

Planning the color sequence

It is best to plan the color sequence for printing the image before you actually begin. You may wish to use the same or another color or any combination thereof. It frequently works well to commence with the brightest warm color and finish with a cold transparent one, perhaps using some shade of blue. If the print is too hot or bright, it may be subdued and modified by the addition of a thin coating of grey or blue. If the image is too cold or dull, it may be given warmth by a coating of a color inclined toward red. Two useful sequences of color are: red, red and black, burnt sienna and black, and cobalt blue; or: red and raw sienna, black and burnt sienna, sepia brown and cobalt blue. Keep in mind that the print will be no darker nor have a greater depth of tone than the amount of pigment in the emulsion. For example, if an emulsion of black has so little pigment that it appears grey, it follows that the deepest shadows of the picture will be grey.

Local application of color

Although the emulsion is most frequently applied over the entire image area, it is possible to devise methods for local application to small selected sections. This approach may involve sophisticated techniques using an air brush or perhaps in the process of coating, the use of two or three different pigmented emulsions—blend them on the print in one operation, producing a many-colored impression in one printing. Artist's maskoid, available at an art supply store, is useful for this purpose. It is a liquid rubber that may be applied with a brush and when dry will not allow the emulsion to penetrate its surface. All that is needed to remove it from the paper is a gentle rubbing with an art eraser. Color may also be brushed away from any part of the emulsion where it is not wanted, prior to exposure, with the use of a brush, blotting paper and water.

So varied are the possibilities of multiple printing that it is even useful to expose the print face down without a negative (once a few initial coatings have been made). In this case, the light passes through the paper and effects the sensitive surface of the emulsion through the spots left transparent by the negative in former printings—the print acting as its own negative.

Step Twelve: Print Stabilization 12

Paper prints should be cleared only after the last printing is complete. Since the paper dimensions are frequently altered by the "clearing agent," any further accurate registration is impossible.

Allow the print to dry thoroughly after the last development, then soak it for five minutes in a five percent solution* of potassium metabisulphite. It is unlikely that the emulsion will soften at this time but in any case be careful to prevent any abrasion. Transfer the print to a running-water rinse at 20°C for ten minutes, then hang to dry.

The print will now be chemically stable and ready for presentation. If necessary, it may spotted with watercolor. Although it isn't required, the image may be protected by spraying it with a product such as those used for fixing crayon, pastel or charcoal drawings.

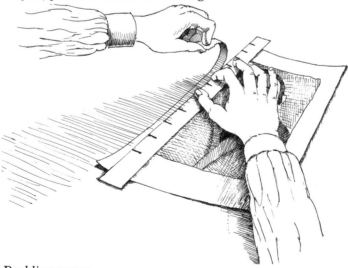

Deckling paper

The appeal of the finished print may be improved by deck-

ling the paper's edge. Lay a rule over the front of the print and carefully tear off the excess paper by pulling it straight up to create a jagged hand-torn impression. The paper seems to give the most pleasing edge when deckled by tearing a strip only about ¼" wide. If more than that amount needs to be torn, first remove the larger section with one tear and leave the required amount for a second pull. Study various prints in graphics galleries to observe how the paper's edge appearance influences the image presentation.

Appendix A: Special Techniques

Flashing

Reducing contrast by pre-exposure

There will be occasions when the contrast of the enlarged negative is too great to obtain the print quality desired. Although there are a vast number of sophisticated methods you may use to reduce contrast, flashing works well in the majority of cases. It involves exposing the enlarged negative material to white light prior to making the actual image exposure.

To determine the correct flash exposure, remove the original negative from the enlarger negative carrier and place a sheet of the film being used to duplicate the original negative in the easel. This can be done with either a duplicating negative film or an inter-positive. Make a test strip, exposing the film to the white light of the enlarger to determine the inertia exposure (minimum amount of exposure necessary to produce the first noticeable change in density of the film).

Once this time is determined (say it is ten seconds at an aperture of f/11), reduce the time by ten percent (to nine seconds), and flash another sheet of film. Replace the negative in the carrier and make a test exposure on the flashed film to determine the proper main exposure for the negative. Then proceed to make the full enlargement giving the consecutive flash and main exposure.

Negative Masking

Accurate methods of dodging and burning-in are possible with the use of masking films such as those made by Ulano in New York. These are "light safe" stripping films coated on a polyester backing sheet. The precision possible with their use is particularly helpful in consideration of the low sensitivity of the gum bichromate emulsion and the necessity for long exposures.

Ulano products are available in art or screen-process supply stores. In addition to the film itself, a swivel knife for cutting the film is also required, available from the same supplier.

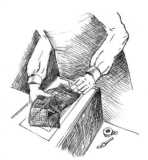

Hinging rubylith over negative

The procedure involves determining the polyester backing side of the film; using tape, hinge a piece large enough to cover the entire negative. Be certain that the stripping film is hinged with the backing (shiny side) in contact with the negative.

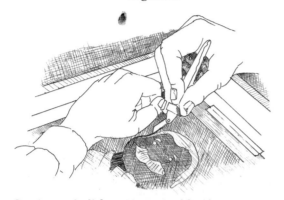

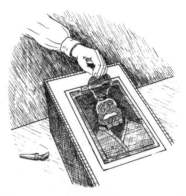

Cutting rubylith using swivel knife *Removing rubylith*

Working on a light box, cut through the stripping film outlining the areas to be masked. Use light pressure only. Do not apply so much force as to cut into or through the polyester backing. Gently lift and peel off the stripping film where cut, leaving open the areas that are to receive additional exposure.

Border Masking

The aesthetic appeal of many images may be improved by having sharply defined border areas as opposed to the irregular border effects created by the manner in which the emulsion was brushed on the paper.

Prior to printing, place the enlarged negative on the light box and using a ¼" hog's hair brush, apply a liquid opaque such as that manufactured by Kodak, forming an image

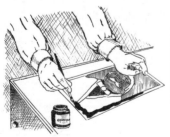

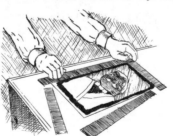

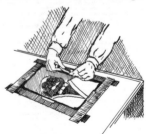

Applying liquid opaque to the negative borders

Positioning construction paper over borders

Taping paper onto negative

border of the type you desire. Opaque is manufactured for working on negatives in this manner and is extremely suitable for this use. Once the opaque has dried, hinge strips of black construction paper along all four sides of the negative. They must be of adequate length and width to protect any print emulsion from exposure that is not within the actual image area. During development, the margin which has been shielded by the liquid and paper opaque mask will begin to discharge its pigment.

If any pigment in the exposed margin binds to the paper, it should be lightly brushed off during development to prevent permanent staining.

Print indicating borders which were unmasked

Print with masked borders

Appendix B:
Problems and Causes

The more common problems that seem to occur for the beginning gum printer are those that relate to "staining." Stains may be apparent when the highlight or unexposed areas do not clear following exposure. Blotches and stains might also appear after the emulsion has dried on the paper prior to exposure. Because of the wide variety of causes that may lead to these problems, each one is difficult to analyze and correct. The following list of potential problem-causes may be used for reference when attempting to eliminate stains should they arise:

- Manufactured pigments of low quality.
- Light source overheating emulsion.
- Impurities in low-quality printing paper reacting with emulsion chemicals.
- Chemical grades of low purity.
- Sizing is inadequate or uneven.
- Chemicals have been prepared with impure water.
- Improper proportions in the emulsion formula — most commonly the gum solution too thin, or too much sensitizer, or too much pigment in the emulsion.

Appendix C:
Print Editioning

Editioning prints and maintaining records following the standards and practice of fine art printmaking, aside from being functional, may often elevate the monetary value of a print and promote its acceptance by galleries, museums and the public in general.

Increasing the value of prints by assigning edition numbers

The Print Council of America, a group of scholars who meet irregularly to read and hear scholarly papers on prints, sponsors an excellent informative book that should be acquired by all photographers. Written by C. Zigrosser and C. Gaehde, it is titled *A Guide to the Collecting and Care of Original Prints*. They state the following:

> An original print is a work of art, the general requirements of which are:
>
> 1. The artist alone has created the master image in or upon the plate, stone, wood block or other material, for the purpose of creating the print.
>
> 2. The print is made from the said material, by the artist or pursuant to his directions.
>
> 3. The finished print is approved by the artist. These requirements define the original print of today and do not in all cases apply to prints made before 1930.[31]

Note that it is not imperative that the printing be carried out by the artist to produce an original print. But it must be up to the standard demanded by the artist. If the artist does the printing, often the letters "imp" standing for impressit (has printed it) may follow his signature on both the print and collector's print documentation.

Zigrosser and Gaehde discuss photography with considerable regard:

> Although photomechanical methods of reproduction have been discussed in this booklet, nothing has been said about photography itself as a form of printmaking. For photography is a form of printmaking, and, like the other print mediums, is capable of both utilitarian and

aesthetic use. In the early nineteenth century the researches of Louis Daguerre, Nicéphore Niépce, William Talbot, and others brought about the perfection of the photographic process — a device for fixing an image on paper or glass plate, and later on film, by purely optical and chemical means, and then printing from that negative. The daguerreotype, being a unique positive, cannot be classed as a print. The camera can objectively and impersonally translate whatever appears before it in terms of light and dark upon the plate. The subjective factor is the selective eye of the photographer. If nature, or any object, is to be copied, photography can do it more quickly and cheaply than any artist can. And seemingly more accurately, because the copyist's personality is not obvious. It must be remembered, however, that photography is really only another pictorial convention and that the camera's eye also has a kind of "personality" or idiosyncrasy, since its diverse-angled lenses and monocular vision (as opposed to human binocular or stereoscopic vision) produce not only variations but also distortion from "reality." But photography is so universally used and accepted that we have adopted its conventions as the last word in accuracy or "realism."

The photograph as a print

Today, photography is the great documentary medium. Although most of its applications have been utilitarian and documentary, the medium has been employed to create original and conscious works of art — in other words, original prints. Witness the prints of such master photographers as Alfred Stieglitz or Edward Weston, to name but two. It has been said that photography could not be an art medium because all its operations are mechanical. All the print mediums have mechanical elements, which the artist has learned to manipulate and control. There are enough variations in the steps of the photographic process to give the artist a wide repertory of expressive devices: lighting and arrangement of materials, choice of lenses, changes of focus, variations in development and printing, including solarization. There is no logical reason, then, why a photograph cannot be a work of art if it is made by a conscious artist. The subject is vast and complex and could easily fill a book. It is introduced here briefly for the sake of completeness.[32]

There are four principle types of printmaking: relief*, planographic*, intaglio* and stencil*. Although gum prints most resemble images produced by lithography, they do have many unique characteristics. Unlike lithographs, gum prints are not produced in a press. Whether or not the gum print can specifically fit into one of the four principle graphic arts media

is not important, particularly now that experienced collectors and knowledgeable dealers understand their value. For this reason some print galleries may show photographic gum prints and disregard conventional silver prints. It is vital to acquire some knowledge in the field by studying prints, reading books or catalogues on prints and collecting, and trying to find a reputable established dealer.

A multiple is an original work that exists in duplicated examples, each of which is an original. As with any form of print, gum bichromates may exist as multiples although it is unlikely that two prints are ever exactly alike. In this sense, gum printing may be compared with etching, where effects are dependent on the wiping of the plate, the amount of oil or ink used, and the heat of the plate. Expert copper plate printers can re-print uniform impressions and there is no reason why gum workers should not be equally successful, provided the effort is made.

"Artist's proof," or "bon à tirer" as it was traditionally called in France, is a valuable term. It was used to indicate the first print to meet the artist's approval, which is reserved for the artist's personal use outside of the edition. It may also indicate that the print does not form part of an edition but may still exist in multiples equal to the quality of the edition, usually limited to ten percent of the total. It is regarded as more valuable since it has an added personal association with the artist. Because of the flexible nature of gum printing, which lends itself to making each print with a unique nature (much like that of a monotype*), this is a useful term for printers who vary their methods from print to print.

Many artists only sign prints and mark them as "artist's proof" regardless of the number produced. They feel numbering is without significance except for the purpose of making sales and protects only the dealer and collector. However, editioning requires some kind of record keeping and for that reason individual print numbers are extremely functional as serial numbers. The printmaker may choose to keep a worksheet which classifies the print by name and number, the time during which the print was made and a full description of colors, sequence, techniques and dimensions of the image. The size of an edition may range from a small number of ten or twenty to two thousand. It is usually preferred that the edition be small in order to ensure the value but it is impossible to speculate on this. Editions today are smaller than they were in the past, perhaps because so many artists do their own printing and are reluctant to spend too much of their time doing so. But if it is claimed that an edition is limited, it must in fact be limited. Each print should bear an indication of the maximum size of the edition.

Using a medium pencil, either the print number and edition size, or the words "artist's proof," (abbreviated AP) are written on the lower left side. The title is written in the middle, and

Definition of print-makers' terms

The importance of sequential numbers

the artist's signature at the lower right, and if desired, it is followed by the year of production.

The numbering sequence generally indicates the order in which the prints were produced, although this is not necessary with gum printing. With gum prints as with serigraphs (stencil printing), each consecutively numbered print is of equal value, since the techniques are nondestructive to the quality of each progressive print. In drypoint etching (intaglio printing), this is not the case, since each pull of the press weakens the bite of the zinc or copper plate, until the loss of quality becomes significant.

In addition to the multiple edition and the "artist's proof," it is possible to have another category of print known as the trial or "working proof." For example, in order to develop a suitable gum print, the artist may experiment with several different color combinations, brush work and masking. Though some may not be satisfactory or only represent tests and unfinished states of an "artist's proof," they may still be quite interesting and attractive. They should be marked "working proof" and numbered in the sequence pulled. They should not be considered part of the finished edition.

When printing is complete, the edition must be cancelled. In some cases, to prevent the production of unauthorized prints, the negative or plate may be destroyed or defaced.

A printmaker should keep track of his collectors, giving them authorized receipts following purchase. A suitable plan may be found in any book on art sales.

Appendix D:
Chemical Formulas

Note: The following are the sources for the various chemicals and materials needed: photographic and graphic arts dealers, drug stores, chemical supply houses, science shops and art supply stores.

When purchasing chemicals for photography, it is found that some chemicals, e.g. silver nitrate, are usually only available in high purity grades. In other instances, you may be able to select a specific "photo grade." Chemicals branded this way are supplied especially for photographic use. The manufacturer employs analytical and photographic tests to ensure that a satisfactory and standard product is supplied at a fair price. He also distinguishes between impurities which are harmless and those which are undesirable. However, in most cases you have to make a choice from the varying qualities and should be familiar with their proper classification. A guideline is as follows:

Analytical Reagent (A.R.)

This is a general term used as the standard commercial designation to describe the highest purity and thus the highest cost. This degree of purification is not usually necessary for photographic purposes. The specifications for the A.R. grade are standard, although the methods of testing used by different countries may vary. The ones widely used in North America are:

American Chemical Specification — A.C.S.
Great Britain and Commonwealth Countries — ANALAR

Pharmaceutical

This is a medium standard and the alternative one to use when a photographic grade is unavailable. This grade is suitable for gum printing. If there is any problem obtaining good results or should you suspect there is an impurity in the chemical as indicated by a constant sediment, then you

should try an analytical reagent. As with the A.R. classification, pharmaceutical grade may be designated by varying labels:

United States Pharmacopeia — U.S.P.
United States National Formulary — N.F.
British Pharmacopeia — B.P.

Commercial, Technical and Unbranded

These grades present an element of risk. There are no guarantees against variation from batch to batch or against the presence of undesirable impurities. Try to avoid having to resort to these low quality chemicals.

NOTE: Photographers and laboratory workers frequently wish to know how to substitute one chemical for another. Generally speaking, there is little to be gained by substitution of chemicals in formulas. The information contained here should not be construed as recommended procedure, but merely as suggestions which may be called for by special necessity.

Albumen

Complex organic compound at one time much used in photography for making albumenized paper — an early type of daylight printing paper. For this purpose it was prepared from the white of egg, which is almost pure albumen.

Ammonia

SYNONYMS: Ammonium Hydroxide, Ammonia Solution
FORMULA: NH_4OH
MOLECULAR WEIGHT: 35
CHARACTERISTICS: Colorless aqueous solution of ammonia gas; strong alkaline reaction; caustic; tending to enlarge grain structure of negatives, hypersensitizing film.
CHEMICAL WARNING: Use in well-ventilated room to avoid intense, pungent, suffocating fumes.

Ammonium Dichromate

SYNONYM: Ammonium Bichromate
FORMULA: $(NH_4)_2Cr_2O_7$
MOLECULAR WEIGHT: 252
CHARACTERISTICS: Used as a sensitizer for the carbon, carbro, gum bichromate and other photomechanical processes; freely soluble in water at room temperature; orange

crystals; has a stronger sensitizing power (approximately 2X) and is more soluble than potassium salt. When in contact with a colloid, it is decomposed by light and renders the colloid insoluble.

SUBSTITUTIONS: For every 100 parts, substitute 117 parts potassium or sodium dichromate.

CHEMICAL WARNING: Chromates are highly poisonous. They are readily absorbed by the skin and give rise in some people to extremely dangerous indolent ulcers all over the body, generally on the hands and arms. When mixing, do so in open air holding breath or use an inexpensive surgical filter mask; wear gloves and eye protection; wash dust away immediately afterwards.

Arrowroot

SYNONYM: Maranta (West Indian)

CHARACTERISTICS: A prepared pure starch obtained from various plants, the finest being West Indian. English arrowroot is the starch obtained from potatoes. Arrowroot forms an almost clear solution when melted. It can be used for sizing papers before sensitizing in about 2 or 3% solution and also as a mountant.

Chrome Alum

SYNONYMS: Chromic Potassium Sulphate, Potassium Chromium Sulphate

FORMULA: $CrK(SO_4)_2 12H_2O$

MOLECULAR WEIGHT: 499

CHARACTERISTICS: Red-violet to black crystals forming a purplish solution. When heated or in the presence of sulphite, the solution gradually turns greenish and loses its hardening properties within about twenty-four hours. It is used as a hardener in stop and fixing baths and with gelatin size in gum bichromate work; fairly soluble in water at room temperature. Its tanning action is greater than that of ordinary white alum and is capable in favorable circumstances of raising the melting point of gelatin to over 93°C.

CHEMICAL WARNING: See potassium alum.

Formaldehyde

SYNONYMS: Formalin, Formic Aldehyde, Formol

FORMULA: HCHO

MOLECULAR WEIGHT: 30

CHARACTERISTICS: Pure formaldehyde is a gas but is supplied commercially as a colorless 37% aqueous solution with about 9% methanol as a stabilizer; has a biting pungent odor; used for hardening gelatin films in contemporary work and as a hardening agent for paper size with gum

printing. Its action on the gelatin is not the same as that of the alum hardeners — it is used more where hardening in a neutral or alkaline solution is required since the alum is totally ineffective in that case.

CHEMICAL WARNING: Poisonous; vapors attack mucous membranes of eyes, nose and throat, causing intense irritation.

Gelatin

CHARACTERISTICS: A product obtained by boiling animal skins, tendons, bones, ligaments, hooves, etc. with water. This is not a definite chemical compound and a given sample will contain molecules of various molecular weights. As a naturally occurring protein it has both acid and basic properties. It contains carbon, hydrogen, nitrogen and oxygen, with a small portion of sulphur. It is insoluble in cold water, which it absorbs and then swells up to a slimy mass; it is soluble in all proportions in hot water but insoluble in alcohol and ether.

Glycerol

SYNONYM: Glycerin
FORMULA: $(CH_2OH)_2CHOH$
MOLECULAR WEIGHT: 92
CHARACTERISTICS: Heavy liquid with oily properties that is soluble with water in all proportions; chemically neutral; classed as an alcohol.

Gum Arabic

CHARACTERISTICS: Gummy substance obtained from the stem of the acacia. Also occurs in the fruits of certain other plants native to Africa. It is soluble in water but becomes insoluble when treated with certain bichromates and exposed to light. Used in mountants, for sizing paper before sensitizing for certain processes, and as the colloid in the gum bichromate process. Pure pharmaceutical grade acacia is white, from Kordefan in the Sudan and is sunbleached. Solutions may be almost clear to slightly yellow.

SUBSTITUTIONS: Although many other gums exist, there are none that dissolve in water as readily. Should a shortage result, check with your supplier for his recommendation.

Mercuric Chloride

SYNONYMS: Perchloride or Bichloride of Mercury, Corrosive Sublimate
FORMULA: $HgCl_2$
MOLECULAR WEIGHT: 271

CHARACTERISTICS: Made commercially by dissolving mercury in hot hydrochloric acid; easily soluble in water at room temperature.

CHEMICAL WARNING: Extremely poisonous and dangerous to use. Antidote is egg white followed by an emetic. Dust should not be inhaled; skin must not contact solutions.

Potassium Alum

SYNONYMS: Aluminum Potassium Sulphate, Potash Alum.

FORMULA: $AIK(SO_4)_2 12H_2O$

MOLECULAR WEIGHT: 474

CHARACTERISTICS: This is the common alum. Used as a hardener in fixing baths. Colorless crystals or crystalline powder; fairly soluble in water at room temperature; may raise the melting point of gelatin to about 70°C; keeps its hardening properties much better than chrome alum in solution.

CHEMICAL WARNING: All chromium compounds are extremely dangerous. When mixing, do so in open air holding breath or use an inexpensive surgical mask. Wear gloves and eye protection; wash dust away immediately afterwards.

Potassium Dichromate

SYNONYM: Potassium Bichromate

FORMULA: $K_2 CR_2 O_7$

MOLECULAR WEIGHT: 294

CHARACTERISTICS: Used in chromium intensifier and sensitizer for carbro, carbon, gum bichromate and other photomechanical processes. Large orange-red crystals obtained from chrome iron ore. When in contact with a colloid, it is decomposed by light and renders the colloid insoluble; fairly soluble in water at room temperature, freely soluble in hot water.

SUBSTITUTIONS: For every 100 parts, substitute an equal amount of sodium dichromate or 85 parts ammonium dichromate.

CHEMICAL WARNING: Refer to ammonium dichromate.

Potassium Metabisulphite

SYNONYMS: Metabisulphite of Potash, Potassium Pyrosulphite

FORMULA: $K_2 S_2 O_5$

MOLECULAR WEIGHT: 222

CHARACTERISTICS: White crystals smelling of sulphurous acid gas, used as acidifying agent in acid fixers and stop baths, preservative in developers; highly soluble in water at room temperature; highly effective when used as

clearing agent or preservative for removing yellow dichromate stain from gum bichromate prints.

SUBSTITUTIONS: For every 100 parts substitute 94 parts sodium bisulphite or 86 parts sodium metabisulphite.

Sodium Bisulphite

SYNONYMS: Acid Sodium Sulphite, Leucogen
FORMULA: $NaHSO_3$
MOLECULAR WEIGHT: 104
CHARACTERISTICS: White crystal powder with faint sulphurous odor. Used for acidifying fixing baths and solutions of sodium sulphite and preserving stock solutions of developer. May be used as clearing bath for gum prints; fairly soluble in water.
SUBSTITUTIONS: For every 100 parts, substitute 106 parts potassium metabisulphite or 91 parts sodium metabisulphite.

Sodium Carbonate (Anhydrous)

SYNONYMS: Carbonate of Soda, Soda Ash, Washing Soda
FORMULA: Na_2CO_3
CHARACTERISTICS: Colorless crystals freely soluble in water, principle alkali or accelerator used in development.

Sodium Dichromate

SYNONYM: Sodium Bichromate
FORMULA: $Na_2Cr_2O_7 2H_2O$
MOLECULAR WEIGHT: 298
CHARACTERISTICS: Used in intensifiers, bleaching baths and carbon, carbro, gum bichromate and other photomechanical processes in place of potassium or ammonium dichromate but has no advantages — its deliquescence is a disadvantage. It consists of red deliquescent crystalline fragments, obtained in a similar manner to the potassium salt and used for the same purposes. Highly soluble in water.
SUBSTITUTIONS: For every 100 parts, substitute an equal amount of potassium dichromate or 85 parts ammonium dichromate.
CHEMICAL WARNING: Refer to ammonium dichromate.

Sodium Metabisulphite

SYNONYM: Sodium Pyrosulphite
FORMULA: $Na_2S_2O_5$
MOLECULAR WEIGHT: 190
CHARACTERISTICS: White crystals used in acid fixing baths and stop baths and as a preservative in developers; fairly soluble in water; may be used as clearing bath for gum prints.
SUBSTITUTIONS: For every 100 parts, substitute 116 parts potassium metabisulphite or 110 parts sodium bisulphite.

74

Glossary

BAUMÉ HYDROMETER: See Degree Baumé

BICHROMATED COLLOID: Various substances such as albumen, gelatin and gum arabic that dissolve in water but will not diffuse through parchment membrane are classified as colloids. These may be sensitized with the chromium salts of potassium, ammonium or sodium, to have a light hardening effect in what are known as the "bichromate processes."

BLUE SENSITIVE: These materials are most responsive to the blue and near ultra violet light inherent in every silver-halide emulsion. Generally, they are used in specialized work such as with masking or halftone duplication and have the advantage of a high tolerance to safelight illumination.

BRACKET EXPOSURES: Even with the aid of modern sophisticated exposure calculators, there are occasions when we are unable to be absolutely certain of the best exposure to give. If the photograph is important, we must resort to "bracketing," or the making of a series of separate exposures. For this purpose it is generally useful to make three exposures, one at the most likely value and the other two a stop or so on either side of this.

BROMIDE (DEVELOPER, PAPER): The most popular type of development paper for making enlargements. The sensitive salt with which the paper is coated is silver bromide, usually with a small silver iodide content, in gelatin.

CARBON ARC: Carbon arc lamps are employed in the photomechanical trade where high intensity is required. They are classified as low intensity, high intensity, and "white flame" arcs. They range in color temperature from 3,800°K to 10,000°K. High intensity lamps sometimes allow control of the spectral distribution of light.

75

CLEARING BATH: Any bath included in the processing of a negative or print to remove stains or in some cases neutralize chemicals left by a previous operation.

COLLOID: See Bichromated Colloid

COLOR TEMPERATURE: See Kelvin Scale

CONTINUOUS TONE IMAGE: A positive or negative print or transparency which is composed of a range of densities from black through grey to white and where the greys are formed by varying amount of silver, dye, or pigment. This differs from a "line reproduction" which is composed of only two tones, black (or a color) and white.

CONTRAST: This refers to the visual or sensitometric photographic difference in the brilliance between one part of the image and another. For example, the range of brightness between the highlights and the shadows as rendered in a negative or print. The contrast range is determined by the type of emulsion used, characteristics of the developer and development time.

CRYSTALLIZATION: If a saturated solution cools, or is further concentrated by evaporation, it becomes supersaturated and some of the dissolved substance will precipitate in the form of crystals.

DEGREE BAUMÉ: Specific gravity of a liquid or a solid is its weight per volume compared to the weight of an equal volume of water. A simple and easy method for determining the specific gravity of a liquid is to use a hydrometer, which is a slender sealed glass tube weighted at the bottom and bearing graduated marks. For accuracy and convenience, hydrometers are usually made with a small range, suitable for use in one type of solution or liquid. In general practice, it is customary to use hydrometers marked with the Baumé scale, though another scale called the specific gravity scale is also available.

DELIQUESCENCE: This is the property of a substance which is capable of absorbing so much moisture from the atmosphere that it finally dissolves in it.

DIFFUSION SHEET: Diffusion sheets such as those manufactured by Kodak are often useful for controlling contrast. The diffusion sheet is positioned in a contact printing frame above the emulsion of the film material during exposure. The contrast is lowered by the refraction of light passing through the diffusion sheet to the film emulsion. A small reduction in image sharpness may also be expected.

DUPLICATING FILM: A special film that yields a duplicate negative by exposing it to the original negative through an enlarger. The available film material may either

be a prefogged emulsion, where the reversed image is produced by the destruction of the latent image by exposure to yellow or orange light (Herschel effect), or it may be film with a diazotype (dyeline) layer which directly yields a negative image from a negative.

ELECTRONIC FLASH: A light source which utilizes the short duration flash of light produced by passing a medium or high voltage charge through a gas-filled tube.

EMULSION: Usually termed the light-sensitive coating or "working" surface of photographic materials. The emulsion is coated on a base.

FINE GRAIN POSITIVE FILM: A low-speed, blue-sensitive film for making positive transparencies from continuous tone or line negatives. This film features extremely fine grain and high resolving power and provides excellent definition, even with a high degree of magnification.

FLASHING: This is a method of varying the contrast of a photographic material by using a brief auxiliary "fogging" exposure in addition to the printing exposure. The higher the proportion of flash to basic printing exposure the softer the result. It is immaterial whether the flashing exposure is applied prior to, simultaneously with, or subsequent to the printing exposure.

FLUORESCENT LAMP: Fluorescent lights are a soft, low intensity, diffused source of light. Their highly efficient design gives off more light per unit of electrical power consumed than any other lamp of comparable life. This makes them particularly suited for photography, since very little of their energy is turned into heat. They take the form of long tubes filled with mercury vapor and have an even glow throughout their length. They can be made to emit light of varying color temperatures, and are particularly valuable in a natural daylight or special color-match tube for professional color correcting.

FORMAT (CAMERA AND ENLARGER): The film size used in a camera determines its format A 35mm camera is commonly referred to as a small format camera, while an 8" x 10" or 11" x 14" camera are good examples of a large format.

HALFTONE IMAGE: Photomechanical halftone reproductions produce the illusion of tone by different sized dots of printed ink. The reproduction simulates a continuous tone image when viewed at the correct distance, as the tones appear to be the result of varying densities.

HARDENER: A chemical, usually potash alum, chrome alum, or formaline, used to toughen the gelatin emulsion, or as in gum printing, the gelatin size. It renders the size less

liable to physical damage, but more significantly for gum printing, it raises the melting point of the gelatin.

HYDROMETER: See Degree Baumé

INCIDENT LIGHT METER: These meters measure the intensity of light falling on a subject (not that reflected from it). The incident light meter is fitted with a diffusing medium over the photo-electric cell.

INTAGLIO: The intaglio process is commonly known as etching or photogravure, depending on whether hand or photographic methods are used. The procedure involves incising into metal the printing areas of the image, leaving the non-printing areas in relief. The image is inked, the surface wiped clean and a print is taken from the remaining ink in the incised areas.

IRRADIATION: This is the result of image spread caused by internal reflections within the emulsion layer.

KELVIN SCALE (COLOR TEMPERATURE): The color temperature, expressed in degrees Kelvin ($°K$) is the temperature on the absolute scale ($°C + 273$). It is used to measure the energy distribution over the spectral range (i.e., the color quality) of a light source with a continuous spectrum that provides a fairly easy working method for comparing and specifying the "whiteness" of illuminants in color photography.

LITHOGRAPHIC: See Planographic

MENISCUS: The correct level from which to read a volume of liquid in a graduate is the bottom of the liquid's curved surface (meniscus) i.e. the lowest level of liquid in the middle of the graduate. With opaque measures,the bottom of the meniscus may have to be estimated.

MONOTYPE: A monotype is a unique print. It is exclusive of multioriginal printmaking, being more like a drawing with printed features. It is most commonly made by painting on a sheet of metal or glass with oil-based inks or paints and either rubbing by hand or running through a press, causing the image to transfer to the paper.

MULTIPLE PRINTING (registration): When making gum prints, single color layers are built up by combining them using some accurate method of registration. In sophisticated printing machines for modern color methods, automatic registration is used. However, gum prints are always registered by hand. Registration marks are required and perhaps the most common method uses pins to punch holes indicating points for realignment.

ORTHOCHROMATIC: Photographically, this refers to emulsions which are sensitive to ultraviolet, violet, blue,

green, and in certain instances, yellow light. No ortho materials respond to the orange and red wavelengths beyond about 5,900°K. They are a considerable advantage for black and white film work in the darkroom, since the film may be safely handled under a red safelight.

PANCHROMATIC: This refers to sensitized materials that respond to all colors of the visible spectrum from ultraviolet, violet, blue, green, yellow, orange, and red. These are the type of materials used in general purpose photography requiring full-color reproduction. Although they may be handled under a dark olive green safelight, this proves to be an impractical darkroom illumination.

PERCENT SOLUTION: A percent solution is a confusing term unless understood and applied in the manner intended. This is because a percent solution may be a:

Weight per volume (w/v)
Weight per weight (w/w)
Volume per volume (v/v)

in each case specifying parts per 100, but all being different resulting amounts. For the purposes of this text, it is to be used in its most common system for photographic purposes: that of weight per volume (w/v). The percentage strength will therefore indicate how many grams of a chemical are dissolved in 100cc of the solution. To make a 10% solution of potassium bromide, for example, dissolve 10g of the solid in about ¾ of the required volume of water and add water to make 100cc. As most chemicals are of greater specific gravity or heavier than the liquid, they should be mixed by adding only small amounts at a time. It might otherwise result in the bottom of the liquid becoming a saturated solution, while the top may be nearly pure water. When mixing more than one ingredient, it is also important that care should be taken in which order the chemicals are mixed. It should usually be in the order of the formula, although this is not a problem for gum work.

PLANOGRAPHIC: The planographic process is commonly known as lithography or photolithography. An image can be drawn on limestone or aluminum plates, by hand-drawn methods or photographic means. While the drawn and non-drawn areas are at the same level, a printed image is possible due to ink-accepting areas and ink-rejecting areas. Gum prints closely resemble prints made using this print-making medium.

PLASTICIZER: A substance that may be used to add smoothness and improve solubility and brushing qualities of powder pigments. Plasticizers should be non-volatile and permanent. Glycerol, syrup and wetting agent are frequently used for this purpose.

79

PRESHRINKING: Paper will usually shrink in area about 15% the first time it has been water-soaked and dried. In order to avoid any multiple printing registration problems, paper must not alter during printing, so a preliminary soaking and drying is given.

REGISTRATION: See Multiple Printing

RELIEF: The relief image is commonly known to the artist as woodcut, lino cut or wood engraving. A matrix or printing surface can be obtained photographically by removing exposed or unexposed areas from a light sensitive layer so that the image is raised above the surface of the support. A photomechanically prepared plate is usually printed as a relief image.

RETICULATION: A fine irregular grain which arises from a physical change in film gelatin. This may be caused by a sudden swelling or contraction caused by transferring the film from a warm to a cold solution, or vice versa.

SATURATED SOLUTION: A solution of a substance in any solvent of such strength that it will not hold any more of the substance in solution. The disadvantage of saturated solutions is that their strength varies with the temperature, most salts being more soluble in hot than in cold liquids. Their use should be avoided as much as possible and all solutions made of a definite standard strength.

SIZE: Raw papers generally need to be sized before sensitizing, because the size fills up the pores and keeps the image on the surface. The sizes most used are arrowroot, starch, and gelatin. The paper can be floated on one of these or brushed over with the substance.

STENCIL: The stencil process is most commonly known as silk screen or serigraphy—the former being a commercial term, and the latter that of fine art. It is possible to produce stencils by hand or photographic methods on a suitable woven material stretched tightly across a frame. The parts not meant to be printed are filled with a glue or other suitable block-out material. The screen is laid upon the image-receiving material and ink is squeegeed across the screen, which forces it through the open areas of the mesh.

WHITE LIGHT: This is a loose way to describe light which is not very noticeably deficient in any particular color. The quality of white light from artificial sources is usually quite different from that of daylight, and different artificial light sources vary greatly among themselves. For the purposes of gum printing, these differences are of little importance compared with the precise requirements of contemporary color work.

80

Footnotes

PREFACE

1. Laszlo Moholy-Nagy, *Vision in Motion,* Chicago, Theobald and Co., 1947, p. 197.

INTRODUCTION

2. Discrepancy on this date varies between 1856 and 1859: W.J. Warren, *The Gum Bichromate Process,* London, Iliffe and Sons, circa 1899, p. 11, states 1859; A. Kraszna-Krausz, ed. chairman, *The Focal Encyclopedia of Photography,* London, Focal Press, 1965, Vol. 2, p. 1165, states 1857; Bernard E. Jones, ed., *Encyclopedia of Photography,* New York, 1974 reprint, p. 425, states 1856.

MATERIALS

3. For a complete listing of manufacturers, size, composition and characteristics of fine art papers, refer to: Clare Romano and John Ross, *The Complete Printmaker,* New York, Free Press (div. of MacMillan Co.), 1972, pp. 282-283.

4. Paul L. Anderson, "Special Printing Processes," *Handbook of Photography,* Keith Henney and Beverley Dudley, eds., London, Whittlesey House (div. of McGraw Hill), 1939, p. 468.

5. Supposedly named after a Mr. Bright: Ralph Mayer, *The Artists' Handbook of Materials and Techniques,* New York, Viking Press, and Canada, MacMillan Co., 1970, p. 541.

6. Alfred Maskell and Robert Demachy, "Photo Aquatint or the Gum-Bichromate Process," *Nonsilver Printing Processes,* Peter C. Bunnell, ed.; New York, Arno Press, 1973 reprint, p. 22.

7. Mayer, p. 669.

8. Unfortunately, color temperature is not a proper indication of the suitability of a light source for gum work. More accurate would be the spectral distribution in the blue-violet wavelengths to which the dichromate is most sensitive.

Since that information is rarely available, we will have to accept that almost all light sources used for photography have some and often the greatest portion of their emission in the required or usable part of the spectrum.

STEP ONE

9. When exposing film material by enlarging methods, always place black construction paper over the easel, below the film, to prevent irradiation.*

10. Exposures must always be bracketed* when using a slide duplicator because of the critical demands of flash exposure.

STEP FOUR

11. Anderson, Paul L., p. 488

STEP FIVE

12. Mixing the entire contents of the tube of pigment necessitates a larger quantity of gum solution, reducing the drainage error that results from measuring small portions.

13. See footnote number 12.

14. Henry G. Abbott, *Modern Printing Processes,* Chicago, Geo. K. Hazlitt Co., 1900, p. 20.

15. Anderson, Paul L., pp. 489-490.

STEP SIX

16. If duplicating film is used for the negative, scrape away part of the opaque emulsion in the corners, as it is otherwise difficult to register.

STEP SEVEN

17. To simplify matters, begin printing with an unaltered black. Later, a selection of the various pigments or any combination thereof may be undertaken. The hue of a pigment mixture may be tested by applying some to a piece of the printing paper being used—the same as a conventional watercolor.

18. Should the room temperature drop below 20°C, some of the dichromate sensitizer may precipitate into a solid, settling at the bottom of the solution. Redissolve it by heating before use.

19. Maskell and Demachy, Bunnell ed., p. 21.

20. Warren, pp. 44-45.

STEP EIGHT

21. Attempt some variations on this method—the blender may even be used to daub the emulsion at right angles,

stippling the entire surface, creating a bold, grainy effect.

22. Maskell and Demachy, Bunnell ed., p. 26.

23. Maskell and Demachy, Bunnell ed., pp. 54-55.

24. Abbott, pp. 9-10.

25. Abbott, p. 17.

26. Abbott, p. 18.

STEP TEN

27. Warren, pp. 68-69.

STEP ELEVEN

28. "All his (Demachy) beautiful work is produced by one printing, and if I had any hope that my readers could attain to his proficiency, I would strongly advise them to give every attention to so doing." (J. Cruwys Richards, *Practical Gum-Bichromate,* London, Iliffe and Sons Ltd., circa 1904, p. 66.)

29. Anderson, Paul L., p. 492.

30. C.B. Neblette, *Photographic Principles and Practice,* New York, D. Van Nostrand Co., 1942, p. 670.

APPENDIX C: PRINT EDITIONING

31. Carl Zigrosser and Christina M. Gaehde, *A Guide To The Collecting And Care Of Original Prints,* New York, Crown, 1975, p. 98.

32. Zigrosser and Gaehde, pp. 68-69.

Bibliography

Books

Abbott, Henry G. *Modern Printing Processes*. Chicago: Geo. K. Hazlitt Co., 1900, pp. 5—39.

Anderson, A.J. *The ABC's of Artistic Photography*. Toronto: Dent Publishing, 1913.

Anderson, Paul L. "Special Printing Processes," *Handbook of Photography*. Edited by Keith Henney and Beverley Dudley. London: Whittlesey House, a div. of McGraw Hill, 1939, pp. 466—506.

Auvil, Kenneth. *Serigraphy*. Englewood Cliffs, New Jersey: Prentice-Hall Inc., 1965, pp. 139—148.

Berger, John. *Ways of Seeing*. London: British Broadcasting Corporation and Penguin books, 1972.

Clerc, L.P. *"Photography Theory and Practice," No. 1 Fundamentals: Light, Image, Optics*. London: Focal Press, 1970. pp. 1—18.

Demachy, Robert. "The Gum Bichromate Process." *The Modern Way In Picture Making*. Rochester: Eastman Kodak Co., 1905, pp. 185—190.

Encyclopedia Britannica. *Graphic Arts*. New York: Garden City Publishing, 1929, pp. 257—266.

Gassan, Arnold. *The Handbook For Contemporary Photography*. Athens, Ohio: Handbook Co., 1972, pp. 91—94, 103—106, 122—123.

Hasluck, Paul N., ed. *The Book of Photography*. London and New York: Cassell and Co., 1907, pp. 199—200.

Heller, Jules. *Printmaking Today*. New York and Toronto: Holt, Rinehart and Winston, 1972.

Horder, Alan, ed. *Ilford Manual of Photography*. Essex: Ilford Ltd., 1966, pp. 7—42, 293—326.

Jones, Bernard E. *Encyclopedia of Photography*. New York: Arno Press, 1974, reprint of: Cassell's Cyclopaedia of Photography. London, New York: Cassell, 1911.

Jay, Bill. *Robert Demachy*. London: Academy editions, 1974.

Kraszna-Krausz, A., ed. and introduced, and Strasser, Alex, selection and commentary. *Victorian Photography*. London and New York: Focal Press, 1942.

Kraszna-Krausz, A., ed. chairman. *The Focal Encyclopedia of Photography*. London: Focal Press, 1965, Vol. 1 and 2.

Kranz, Kurt. *Art: The Revealing Experience*. New York: Shorewood Publishers, 1964, pp. 2 — 3, 14, 222—240.

Levy, Mervyn, ed. *The Pocket Dictionary of Art Terms*. Greenwich, Connecticut: New York Graphic Society, 1964.

Maskell, Alfred, and Demachy, Robert. "Photo-Acquatint or The Gum-Bichromate Process," *Nonsilver Printing Processes*. Edited by Peter C. Bunnell. New York: Arno Press, 1973, reprint: London, Hazell, Watson, and Viney Ltd. 1898, Amateur Photographers Library No. 13.

Mayer, Ralph. *The Artist's Handbook of Materials and Techniques*. New York: Viking Press, Canada: MacMillan Co., 1970, pp. 32—37, 78—79, 293—311, 393—396, 408—413, 537—546, 571—604, 627—640, 669.

McIntosh, J. *The Photographic Reference Book*. New York: Tennant and Ward, 1905, pp. 164, 287.

Miller, C.W. *Principles of Photographic Reproduction*. New York: MacMillan Co., 1942, pp. 173—180.

Moholy-Nagy, Laszlo. *Painting, Photography, Film*. Cambridge, Mass: MIT Press, 1973.

_____. *Vision In Motion*. Chicago: Paul Theobald, 1969.

Neblette, C.B. *Photography Principles and Practice*. New York: D. Van Nostrand, 1942, pp. 669—674.

Pittaro, Ernest M. ed. *Photo Lab Index*. Dobbs Ferry, New York: Morgan and Morgan, 34th ed., 1976.

Richards, J. Cruwys. *Practical Gum Bichromate*. London: Iliffe and Sons, circa 1904, pp. 11—118.

Ross, John, and Romano, Clare. *The Complete Printmaker*. New York: Free Press (div. of MacMillan Co.), 1972, pp. 73, 194, 247—258, 282—283.

Sowerby, A.L.M., ed. *Dictionary of Photography,* London: Iliffe Books, 1961, pp. 357—362.

Sheppard, Julian. *Photography For Designers*. London, New York: Focal Press, 1971, p. 212.

Time Life Books. *Photography Year 1975 Edition*. New York: Time Life Books, 1975, p. 112.

Warren, W.J. *The Gum Bichromate Process*. London: Iliffe and Sons, circa 1899, pp. 11—118.

Wheeler, Owen. *Photographic Printing Processes*. Boston: American Photographic Pub. Co. (1930), pp. 151—156.

Zigrosser, Carl, and Gaehde, Christa M. *A Guide To The Collecting and Care of Original Prints*. New York: Crown, 1975.

Miscellaneous Periodicals

Davis, William S. "Gum-Pigment Printing," *The Camera*, Volume 26: 549, 1922.

Freytag, Heinrich. "Photographic Art Printing Processes," *Camera:* 35—36, 52, Dec. 1970.

Gimbel Brothers. "A German Gum Bichromate Process," *Photo Talks:* Oct. 1907.

Lindley, Thomas, "Bichromate Printing," *Popular Photography, Volume 73:* 124—125, 150, 1973.

Martinez, R. "Pictorialism In Europe," *Camera*. Dec. 1970: 8—26.

Porter, Allan, ed. in chief. "Robert Demachy 1859 - 1936," *Camera.* Dec. 1974: 3 — 46. (Partial reprint from *Camera Work*.).

——————————."Pictorialism," *Camera*. Dec. 1970: 6, 26, 49—51.

W.W.M.M. "Gum Bichromate Printing Made Easy." *American Photography Volume 23:* 5, May 1929.

Warren. "Mr. W. J. Warren on the Gum Bichromate Process," *The Photo-Beacon,* Vol. II (Sept. 1899): 244—245.

Camera Notes

Carlin, W. R. "The Gum Bichromate Process," *Volume 3* (Oct. 1899): 66—72.

Stevens, Chas. W. "Improved Gum-Bichromate Process," *Volume 4* (Oct. 1900): 102.

Commentaries on Herr Watzek and Prof. R. Namias. "Gum Bichromate Process," and "New Bichromate Process," *Volume 4* (April 1900): 239—240.

British Journal of Photography

Tulloch, M.B.."The Gum-Bichromate Process," *Volume XLV* (May 20, 1898): 327—328.

Commentary on: "The Gum-Bichromate Process And Its Alleged Uncertainty," *Volume XLV* (April 1, 1898): 194—195.

Eddington, A. "Gum Bichromate Paper," *Volume XLV* (March 25, 1898): 188—189.

Lewis, Joseph. "The Last Word Upon The Gum-Bichromate Process," *Volume XLV* (Feb. 4, 1898): 78—79.

Pouncy, W. "The Gum-Bichromate Process," *Volume XLV* (Jan. 14, 1898): 29—30.

Bennett, Henry W. "The Gum Bichromate Process," *Volume XLV* (Jan. 7, 1898): 14—15.

Commentary on Herr Watzek. "The Gum-Bichromate Process," *Volume XLVI* (Feb. 3, 1899): 68.

Commentary on: "Gum-Bichromate Portraiture," *Volume XLVI* (Aug. 4, 1899): p. 487.

Commentary on: "Pictorial Photography," *Volume XLVI* (Nov. 17, 1899): pp. 722—723.

Commentary on Robert Demachy. "Gum-Bichromate Process," *Volume XLV* (March 25, 1898): 190.

Mumery, J.C.S. "Gum-Bichromate Process," *Volume XLV* (April 8, 1898): 223.

Commentary on W. J. Ramsey. "Enlarged Negatives," *Volume XLV* (May 13, 1898).

Commentary on: "The Gum-Bichromate Process," *Volume XLV* (June 24, 1898): 409.

Commentary on J. Gaedicke. "The Gum-Bichromate Process," *Volume XLV* (July 8, 1898): 437—438.

Commentary on G. Hanmer Croughton. "The Gum Bichromate Process in America," *Volume XLV* (Aug. 26, 1898): 554—555.

Commentary on P. H. Emerson. *Volume XLV* (Sept. 16, 1898): 594—595.

Commentary on: "Modified Gum-Bichromate Process." *Volume XLV* (Dec. 16, 1898): 804.

Packham, James. "The Gum-Bichromate Process," *Volume XLIV* (Dec. 10, 1897): 789—791.

Commentary on James Packham and John Pouncy. "The

Gum-Bichromate Process," *Volume XLIV* (Dec. 10, 1897): 786—787.

Maskell, Alfred. "The Exhibition of the Paris Photo Club, with some remarks upon the Position of Pictorial Photography In France," *Volume XLII* (May 31, 1895 and June 14, 1895): 341—342, 374—375.

_____. "The Artigue Paper Velours and Direct Pigment Processes," *Volume XLII* (Dec. 13, 1895) 786—790.

Emerson, P.H. "Naturalistic Photography," *Volume XL* (April 7 and April 14, 1893): 211—213, 231—232.

Commentary on D. Clarke. "The Gum-Bichromate Process," *Volume XLIV* (Dec. 3, 1897): 776—777.

Commentary on Ritter Von Scholler. "The Gum-Bichromate Process In Three Colours." *Volume XLIV* (April 30, 1897): 281.

Ewing, Geo. "The Bichromated Gum Process," *Volume XLIV* (March 19, 1897): 181—182.

Pretzl, A.D. "The Bichromated Gum Process," *Volume XLIV* (March 19, 1897): 183—184.

The Beacon

Commentary on: "Pigment Printing," *Volume IV* (May 1892): 139—141. (June 1892): 173—174.

Brown, Joseph B. "A New Printing Process," *Volume II* (March 1890): 53—54.

Exhibit Catalogue

Naef, Weston and Boorsch, Suzanne. *The Painterly Photograph 1890-1914*. New York: Metropolitan Museum of Art, 1973.

Unpublished Manuscripts

Rochester. International Museum of Photography at George Eastman House. Archives: Cat. 81.4 W574 #9998. "The Gum-Bichromate Printing Process," by Leyland Whipple, 1964.

_____. Archives: Handwritten manuscript by Ravell. Accession number unavailable.